# SECRET SEA

**BURT JONES & MAURINE SHIMLOCK**

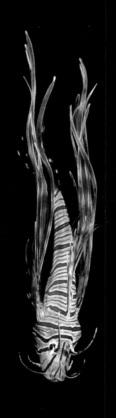

THE OCEAN REALM COLLECTION

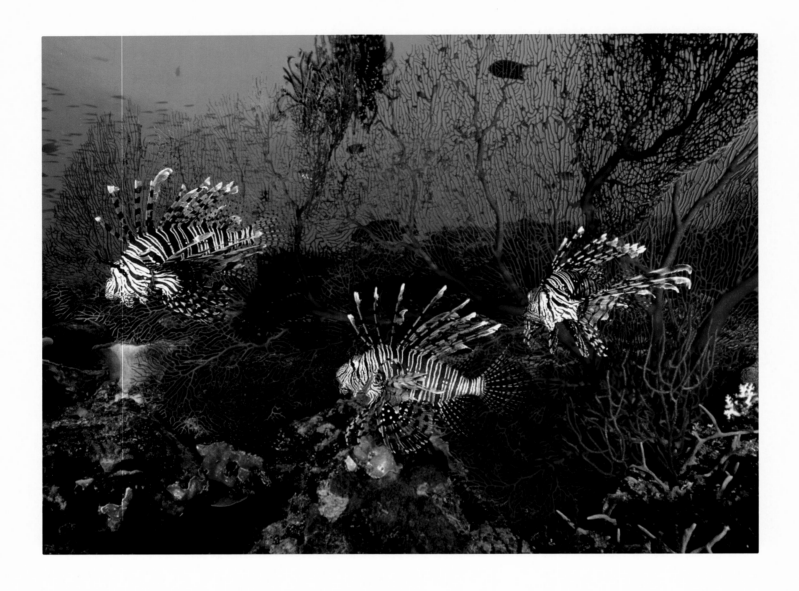

Lionfish

It was a great day for me at the FotoFest in Houston in February 1990, when Burt Jones and Maurine Shimlock, a husband and wife team of underwater photographers, showed me their magnificent views of marine life. I was dumbfounded. I had never before seen such superb creative work of ocean life in tropical waters. Each image was a bijou! I never thought I would start a collection of marine life pictures, but I have. It is enthralling, as you will see from looking at the prints in this book.

Dr. h.c. Helmut Gernsheim
Lugano, Switzerland

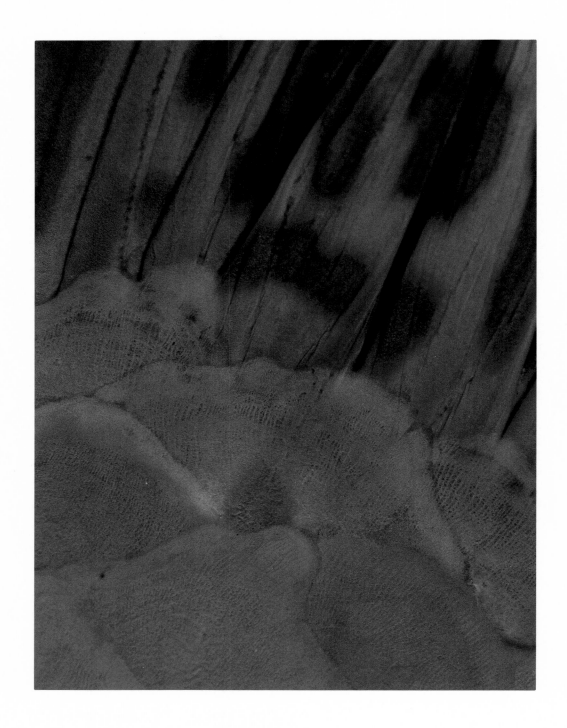

Parrotfish tail

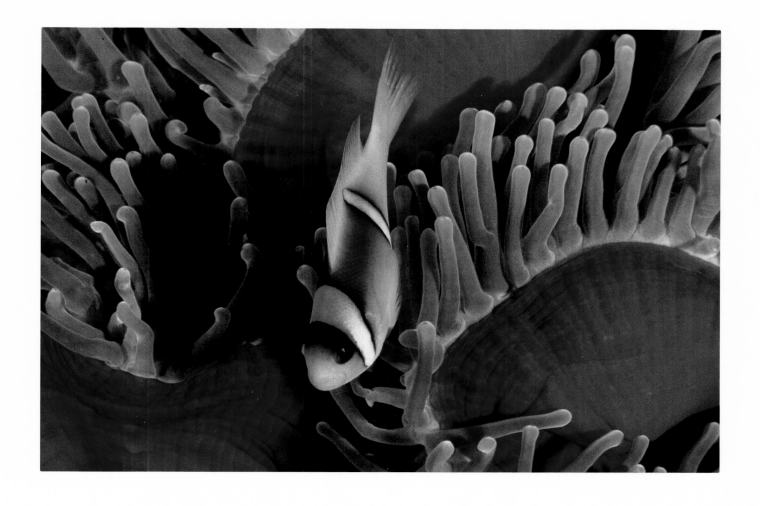

Two-band anemonefish

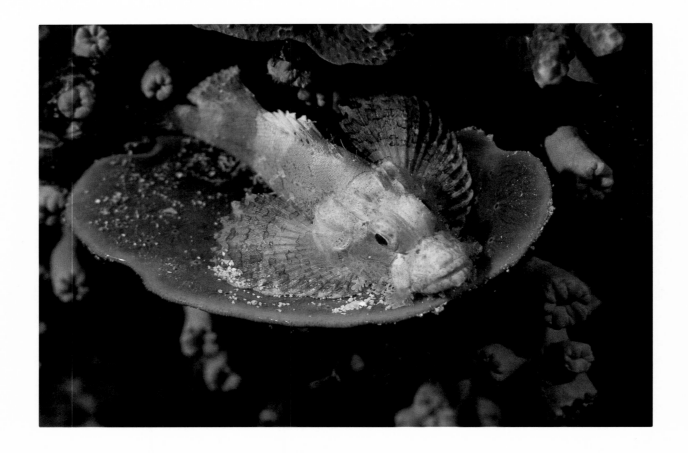

Juvenile scorpionfish

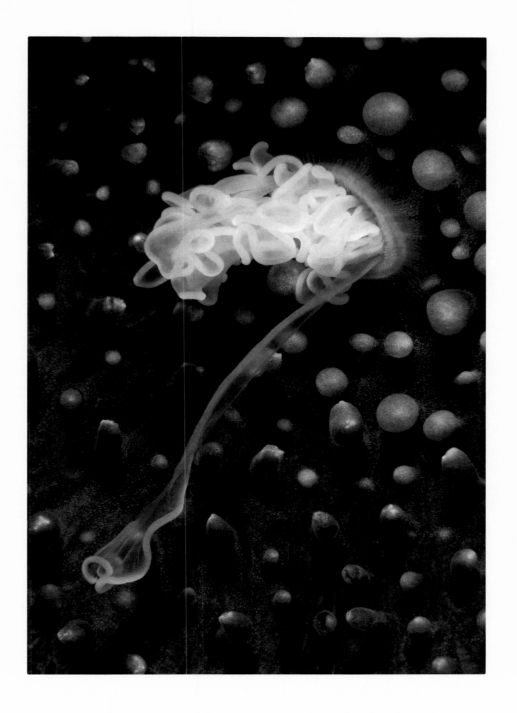

Eviscerating corallimorpharian

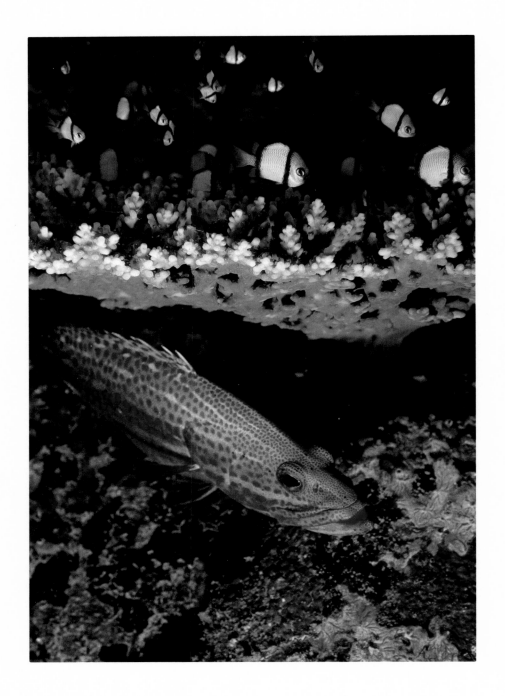

White-lined coral trout

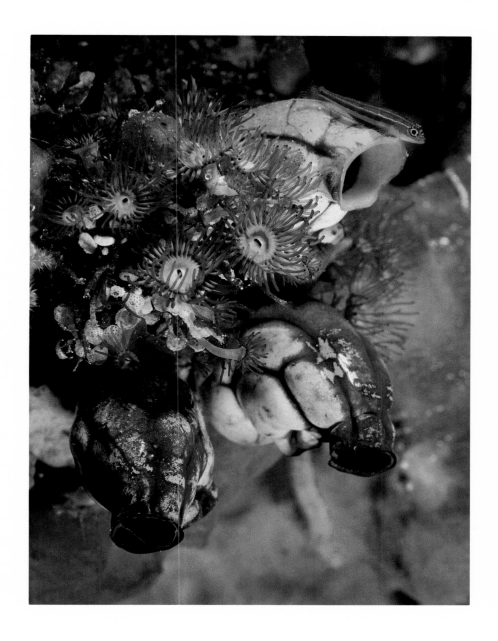

Triplefin on invertebrate collage

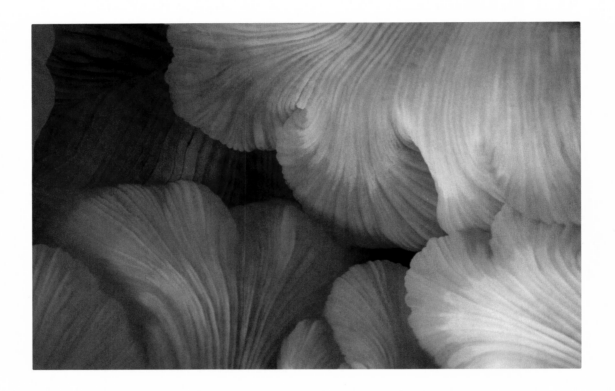

Anemone mouth

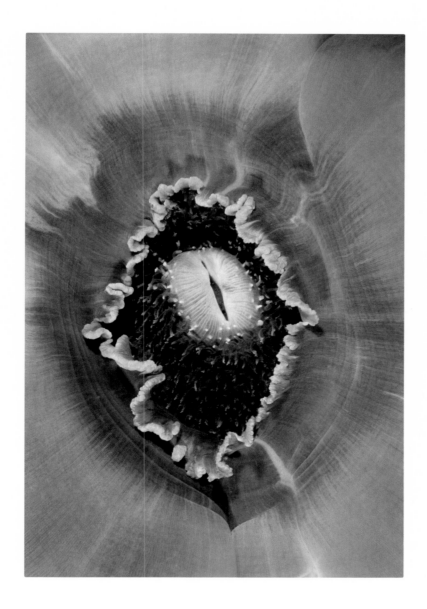

Corallimorpharian mouth

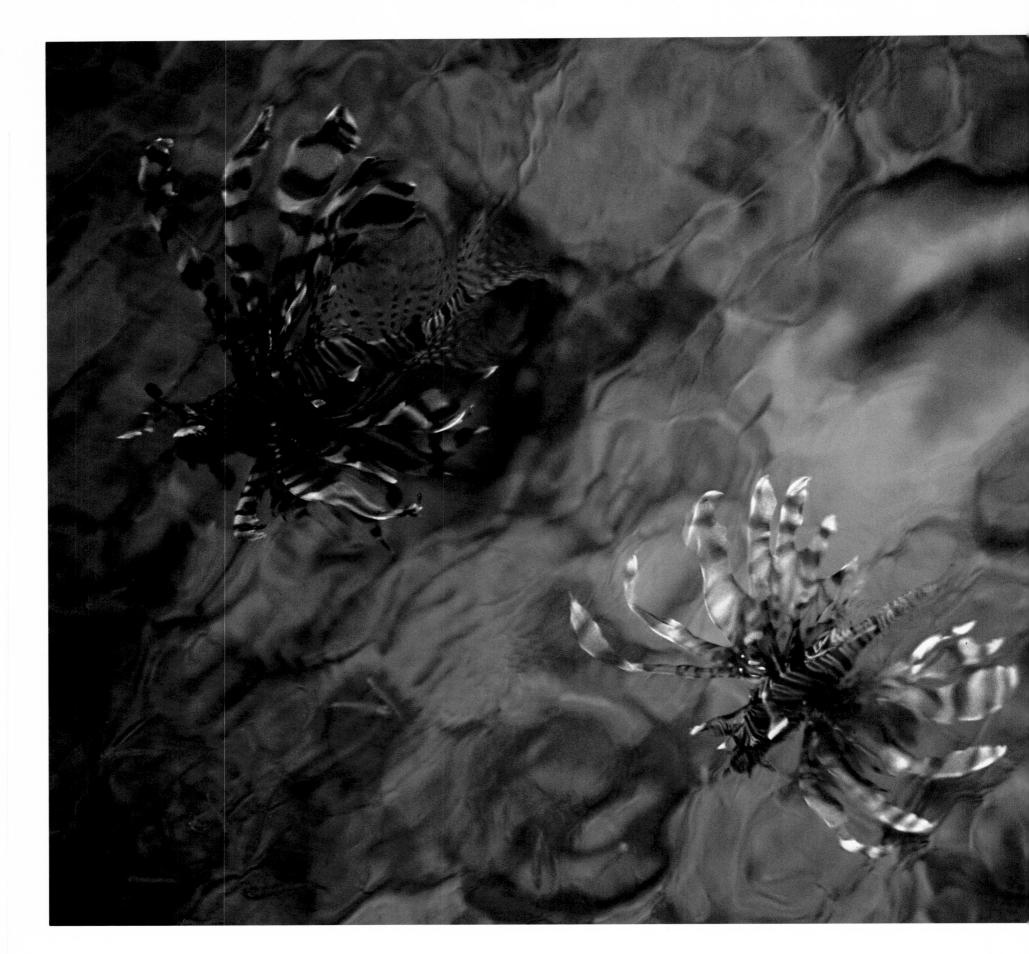

Secret Sea

*SECRET SEA*
Published and distributed by
FOURTH DAY PUBLISHING, INC.
Post Office Box 6768
1067 Broadway
San Antonio, Texas 78209
210-824-8099
210-820-3522 fax

Information regarding these images
may be obtained from the photographers:

Burt Jones
Maurine Shimlock
Post Office Box 162931
Austin, Texas 78716
Phone/Fax: 512-328-1201

FOURTH DAY PUBLISHING, INC.

Library of Congress Catalog Card Number: 95-061625
ISBN: 0-9642736-7-5

Printed and bound in the United States of America.

First Edition.

All animals pictured in this book have been photographed
underwater in natural conditions.
No manipulation, physical or digital, has been
employed in the reproduction of these images.

To encourage the conservation of marine ecosystems,
and to foster the promotion of
environmentally sustainable stewardships
of oceanic resources,
a percentage of profits from the sale of *SECRET SEA*
is donated to non-profit organizations, including Oceanica

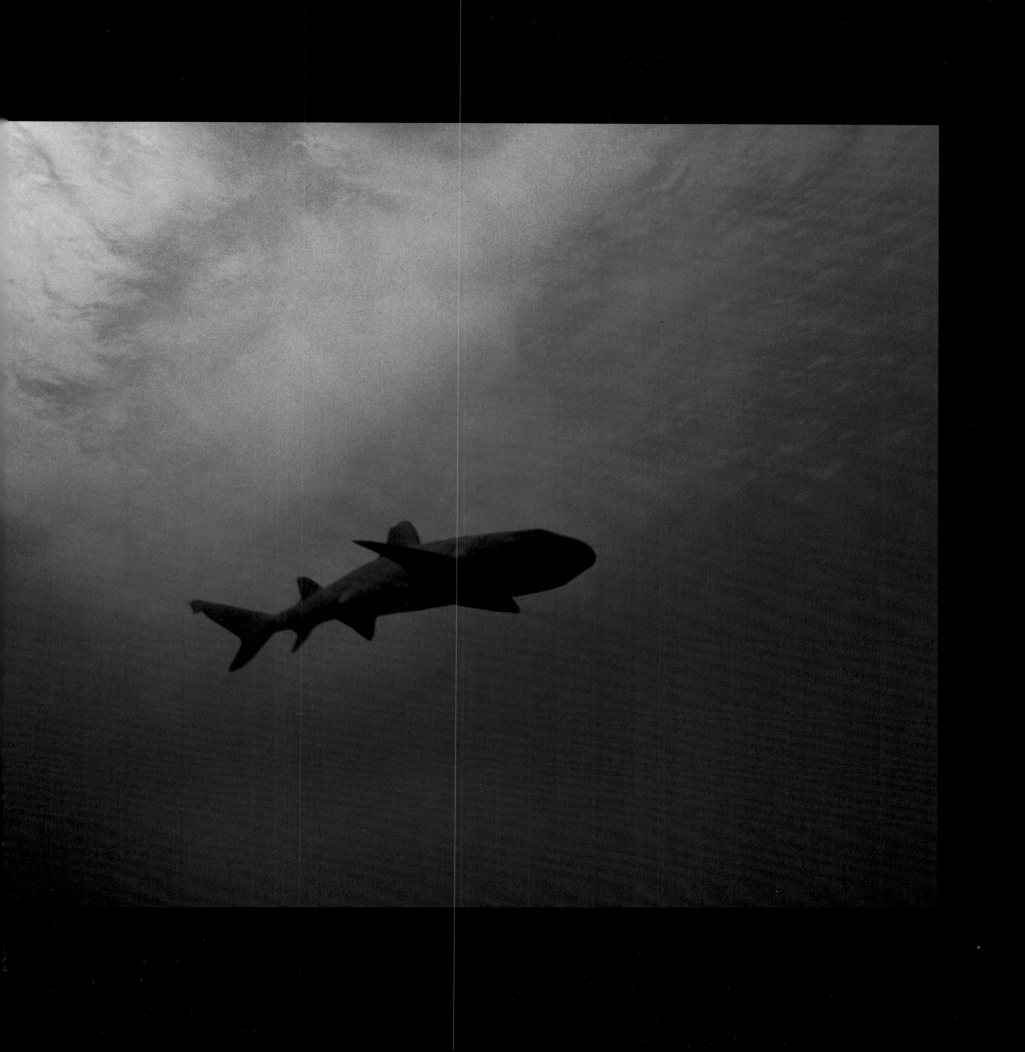

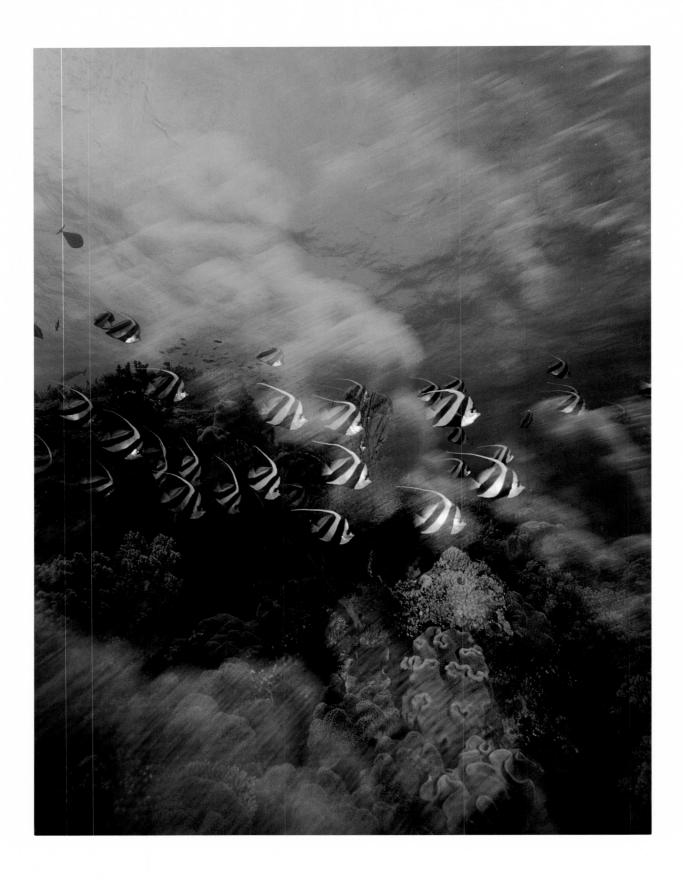

Dedicated to the spirit of
Sangalakki:
To those with courage to care
enough to put protection
before profit.

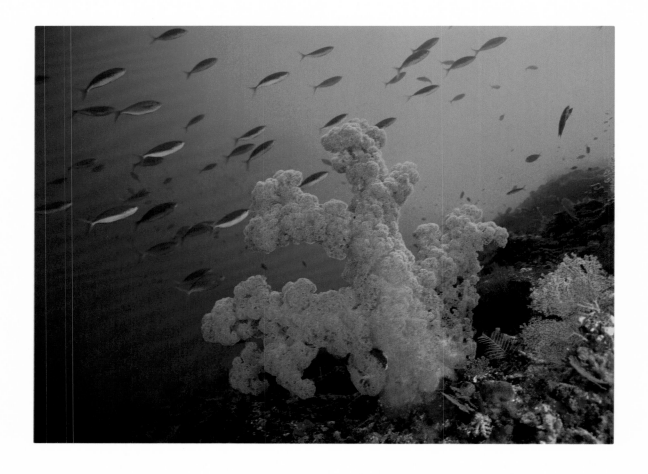

Soft coral and fusiliers

# Visions within the Secret **Sea**

**A late sun and an early moon** hang at opposite ends of a horizonless sky. No wind coaxes the clouds apart. The silver sheen of the dawn sea magnifies their unbroken whiteness. Pulled backward by the universal forces that nourish it, the sea retreats quietly, leaving only a small ridge of evaporating foam and bits of debris to mark the crest of last night's high tide.

Almost imperceptibly, sharp twisted shapes break through the velvety surface of the water. Then small mounds of coral, glistening in the pale daylight, appear above the retreating sea. Walking down the beach we step carefully into a maze of forms and colors, and resist the temptation to classify the reef's disparate creatures, the desire melting away along with our shallow tracks in the moist sand.

**Seeking order of a different kind,** we look for clues that will weld together **this dense population of swaying and pulsating animals** into a harmonious whole bound together by a **tightly woven fabric of shelter and sustenance.**

The day soon grows hotter and whiter, and the subtle hues of exposed corals fade dull, turning milky in the sun. All life seems suspended. But soon the tide begins to pulse around our ankles, and the sea returns, filling in the gaps, claiming the dried-out stubs of coral, and deepening the tide pools with a flood of nutrient-rich water. Fish and crustaceans emerge from their hiding places, and shrunken anemones stretch their tentacles upward to catch the wealth of nutrients the sea brings with it.

When the tide is nearly in, we paddle to the reef crest and dive down. Twenty feet below the surface, the assemblage of animals is intoxicating. Brilliant schools of fish hover above undulating sea whips, nudibranchs glide through ascidian forests, and flower-like fan worms strain sea water through their feathery gills. Our eyes see a fantasy-scape, chaotic and proliferate, but our minds, schooled by our long association with the sea, seek to perceive the hidden processes that regulate the reef's teeming life.

Long ago we came to know the underwater world as hunters, active participants in its cycles of spawning and dying. When we first entered the sea, the myriad relationships and interactions that dominated the life of the reef were practically imperceptible, but as we learned to observe with a predator's eye we began to sense the order that lay beneath the confusion and to understand the deeper symmetry that lay beyond the limits of our sight. Tracking groupers, we saw how the fish would sometimes hover motionlessly in the water while tiny wrasse and shrimp swam in and out of their gill slits and gaping mouths, ridding them of parasites. We grew adept at spotting lobsters from fifty feet away and marveled at their sturdy armament before they wriggled far back in their holes and eluded our grasp.

In those early days, the reef was a giant puzzle, made up of pieces as large as a forty-foot whale shark and as small as near-microscopic diatoms. The more time we spent underwater, the more we yearned to put this puzzle together, to see and to understand the whole pattern. The notion of a secret sea began to emerge in our thoughts: a beautiful design that could be brought into focus only if we learned to perceive its individual threads, and to understand how those threads intertwined with one another.

**All around us** innumerable other creatures experiment with new living arrangements, **forge new bonds, and combine and recombine in dozens of new symbiotic webs.**

It is as if we can feel vast waves of synergetic energy pulsing through the water, **turning the reef's rhythms into a universal song.**

Now we use cameras to help us see more clearly the filaments of life weaving intimate connections between the many different species on the reef, but we rarely catch more than a glimpse of this hidden world. Underwater we are isolated from our normal means of perception. There is nothing to taste or to smell; our hearing is totally distorted, and all we can feel is the enveloping coolness of the sea. Our understanding too is limited; only our sense of sight reveals, layer by painstaking layer, the rapturous mysteries of the ocean.

In the fading afternoon light we are drawn deeper down the reef to a large red-and-yellow sea fan. At seventy-five feet, the color of this mammoth gorgonian's towering skeleton resembles old bricks rather than the stoplight red that soon will leap from our slides. An area of polyps branching off from the middle of the fan appears dull and pale at this depth, but will glow luminously yellow on film. As we hover by the side of the fan facing the current, a colony of brittlestars enchants us by twirling their flexible arms like Balinese dancers and then tightly embracing the main trunk. Two gobies, translucent ring-finger-sized fish, roam over the gorgonian and reflect its color wherever they linger. Curious to determine how many different species live on this fan, we swim around to investigate the opposite side and find a long-limbed spider crab, with ruby chips for eyes, clinging to the network of polyps. A lei of dark crinoids embroiders the fan's upper edge. Their hundreds of feathery arms are outstretched to grab drifting plankton before it is caught by the prowlers below or trapped by the innumerable minute tentacles of the sea fan's polyps.

On a green mound of star coral, a tiny hermit crab inspects a hole abandoned by its previous occupant. The crab backs into the new hole, leaving only its bulging eyes and delicate antennae exposed; it decides this new home is a perfect fit. Nearby, a striped blenny furtively darts about the coral, snatching almost invisible bits of food from the water and feasting on detritus excreted by the coral polyps. In exchange for contributing to its guest's meal, the coral receives an extra bounty: nourishment from the blenny's nitrogen-rich leavings. Concealed behind the pale fleshy polyps of a soft coral tree, we discover a wondrous crab, no bigger than a bottle top. Living polyps, plucked from the coral, decorate the crab's spindly legs and rough carapace. The crab envelops itself within the coral's branches like a treasured object, and within a few seconds we can no longer distinguish the crab from its host.

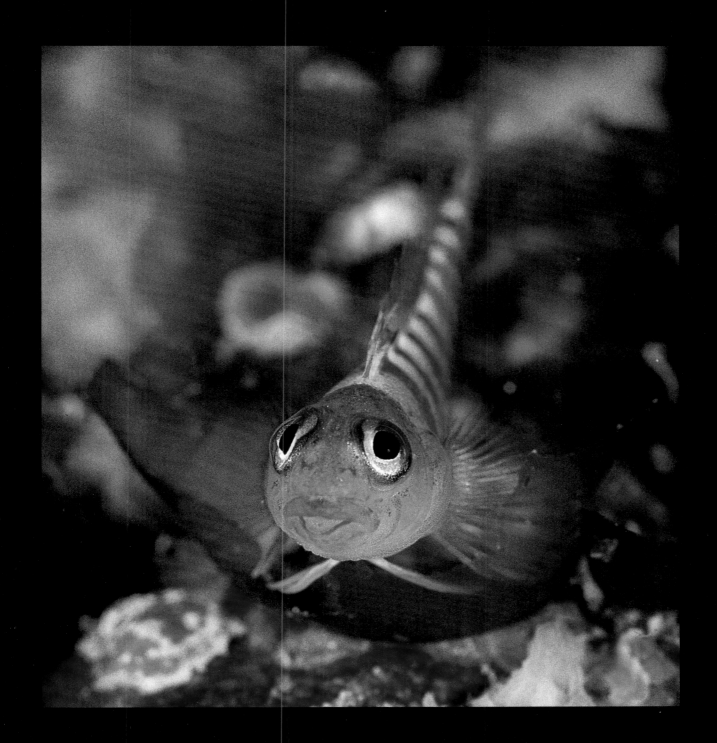

Blue-eyed triplefin

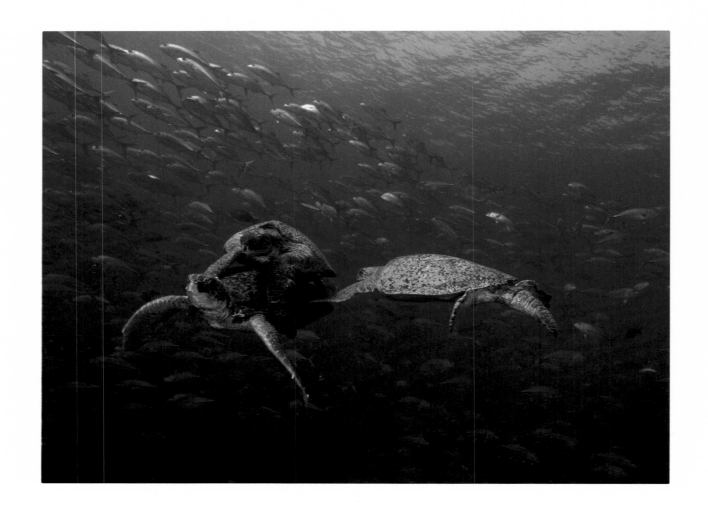

Mating green turtles

As we trace the grand experiment that matches life with life and nurtures the soul of a coral reef, we are surrounded by crucial relationships we will never see. The ocean itself is teeming with life. Caught up in the churning of our fins, a nourishing planktonic banquet of organisms too small to perceive and too weak to swim against the current circulates around us. This abundant life force gives birth to unimagined numbers of marine species sustained by the lifeline of plankton that drifts constantly by them. Some plankton feeders, like wizened, gnome-like tunicates or territory-invading encrusting sponges, have straining membranes that trap the water-borne nutrients. But hard corals, the architects of the reef, are more active plankton feeders. A multitude of tiny individual polyps secrete calcium carbonate and fashion it into huge communal skeletons. Secured within its private calcium burrow, each tiny animal uses minutely barbed tentacles to snatch microscopic planktonic prey from the currents.

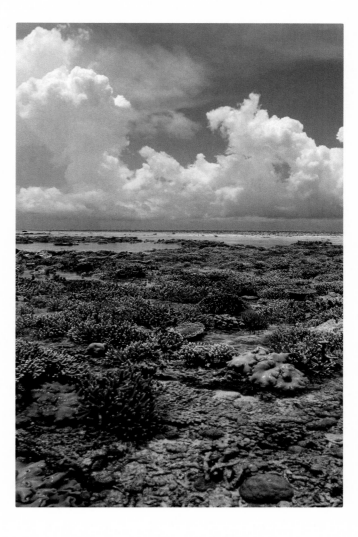

Mesmerized by the rich textures of these massive skeletons, we swim slowly through ancient limestone canyons. Curtains of small pastel-colored fish rise a few feet above the substrate and then dash back into their coral cradles. Shy moray eels slink behind sharp-spined urchins, while blue parrotfish, oblivious to our intrusion into their world, smash delicate corals into bite-size pieces with their bony foreheads. Soon they will discharge the unusable portions as a fine sand.

**How can the coral sustain itself** and still offer sustenance and refuge to so many diverse symbionts and foragers?

One key to the puzzle is that hard corals do not thrive alone. **Hard corals adopt microscopic plants,** single-celled algae called *zooxanthellae*, that make their home within the tissues of the coral's polyps.

The algae **photosynthesize sunlight into oxygen and carbon**, chemical compounds necessary to fuel the polyps' growth, and the coral feeds its algae waste products from digested plankton.

The combination of two of the smallest reef entities, a polyp and a single-celled alga, into living coral reinforces the importance of understanding scale in this environment. On the reef it is important to look at things from the bottom up. We will never comprehend the big picture if we do not pull back the layers and discover the life that teems in the hidden dimensions.

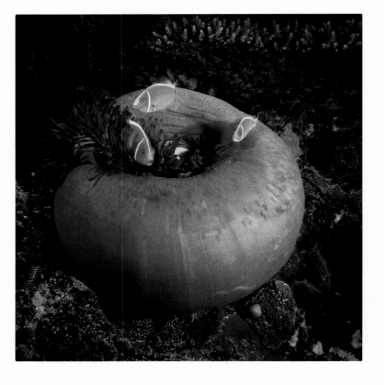

In *Lives of a Cell*° Lewis Thomas writes that if we could only understand the driving force "that brought single separate cells together for the construction of metazoans, culminating in the invention of roses, dolphins, and, of course, ourselves. It might turn out that the same tendency underlies the joining of organisms into communities, communities into ecosystems, and ecosystems into the biosphere." This afternoon, everywhere we look we see Thomas' tendency at work, driving diverse organisms together and binding them into a tightly packed mosaic of communities within the larger world of the reef. Fragile species that might perish alone join up with others. Together they become miniature energy-producing powerhouses that nurture the reef ecosystem and sustain a living mass far greater than themselves.

What alchemy designed this place where one species makes life possible for another, where one animal becomes an entire world for other creatures, and where these worlds within worlds mesh and overlap until all boundaries are blurred? Before us on the reef wall, large anemones lay scattered about like colorful scraps of shag carpet, their poison-tipped tentacles flattened by the racing current. Duplicating the relationship between hard corals and their symbiotic algae, many tropical anemones harbor zooxanthellae in their skin and benefit from the reciprocal exchange of nutrients between plant and animal. Myriad scavenging shrimps and crabs flit in and out of the anemones' tentacles and scuttle around beneath their pastel-colored undersides, each symbiont feasting on the nutritional cornucopia surrounding its host.

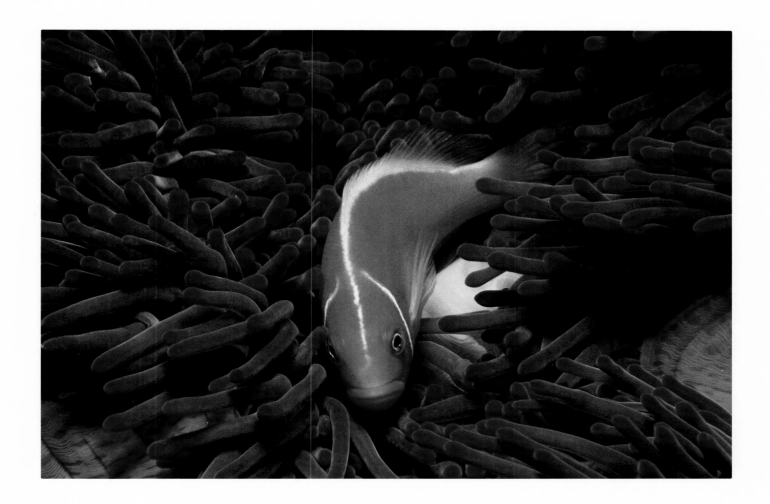

Pink anemonefish

Specialized species of damselfish also pair up with anemones. Protected by a thin mucous coating, a combination of substances secreted by both the fish and the anemone, all anemonefish spend their lives weaving among their host's stinging tentacles in a dance that would mean death to almost every other fish on the reef. Tumbling along in the ever-moving planktonic mass, some larval anemonefish recognize the unique chemical markers discharged by their preferred anemones. Other fish have an innate preference for certain habitats colonized by particular anemones, and still other anemones and fish come together just by chance. Many

anemonefish are selective; only six of the twenty-eight species associate with more than five of the ten species of host anemones. But few are as choosy as the spine-cheek anemonefish that lives only with a solitary form of the bulb-tentacled anemone.

In the wild, anemonefish cannot exist without an anemone, but in aquariums they fearlessly associate with a variety of plants, living or plastic, or even decoys made from rubber bands. Yet all the while they continue searching for the real thing. Anemones can survive on the reef without their attendant fish, but they do not thrive, and they rarely are observed making more than half-hearted attempts to emerge from their substrate crevices. In much the same way that coral flourishes with zooxanthellae inside its polyps and certain crabs camouflage themselves with the living tissue of their soft coral hosts, anemones and anemonefish are so profoundly and inextricably allied that they appear united into a miraculous expression of a greater will.

Nudged toward shore by the darkening sea, we begin to perceive that the reef—not just its component parts—is a living entity. Every animal, perfectly honed for its environment, perfectly machined to fill its unique ecological niche, is but a building block of the larger design.

Magic and vibrant, the reef holds us hostage to our desire to understand it, to follow the links in the chain— creature-to-creature, world-to-world— until we discover the secret whole.

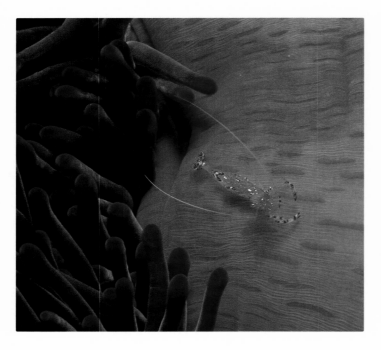

Cleaner shrimp on anemone mantle

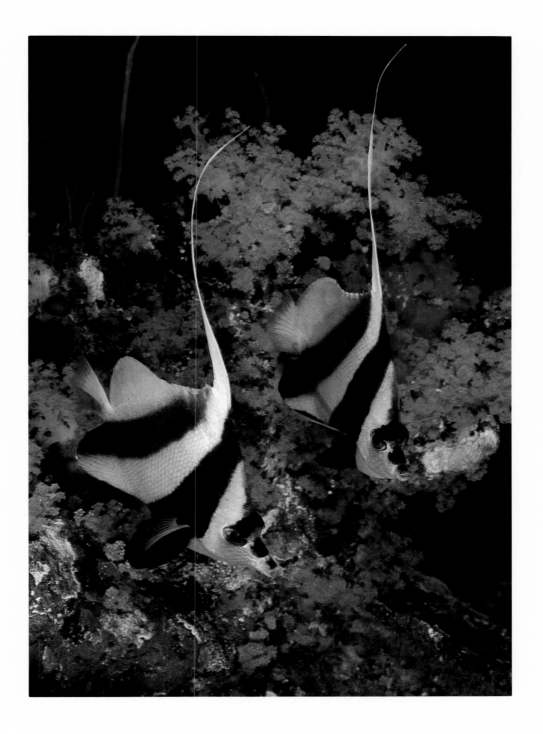

Pair of longfin bannerfish ▪ The creatures living on the reef cooperate and compete with each other with such intimacy that it becomes difficult to think of them as individuals.

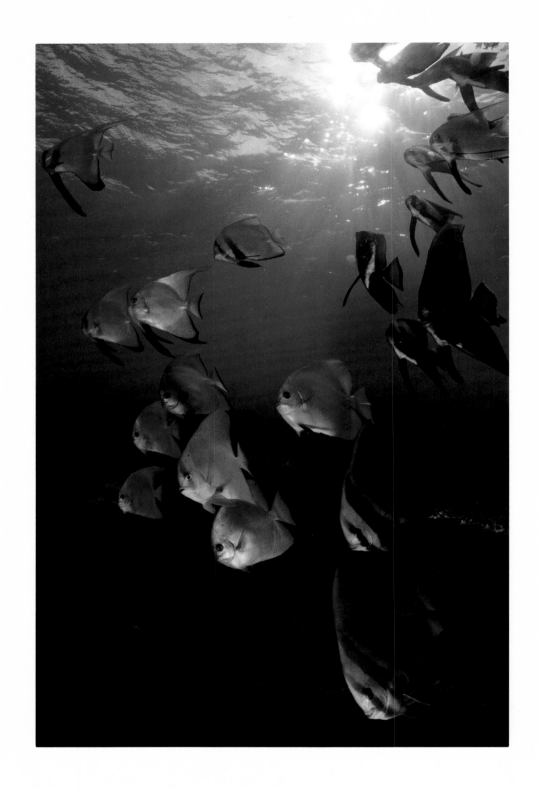

Teira batfish

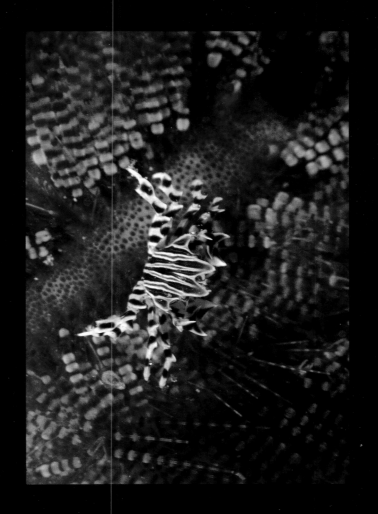

Zebra crab on poisonous urchin

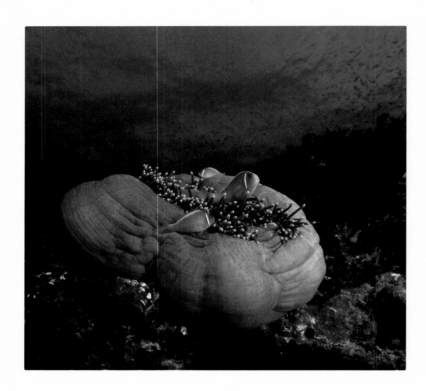

Pink clownfish with host anemone

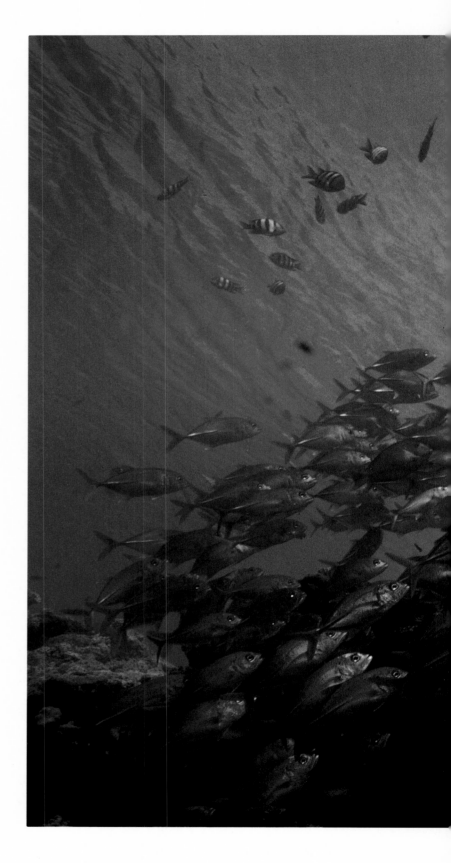

Jacks over reef

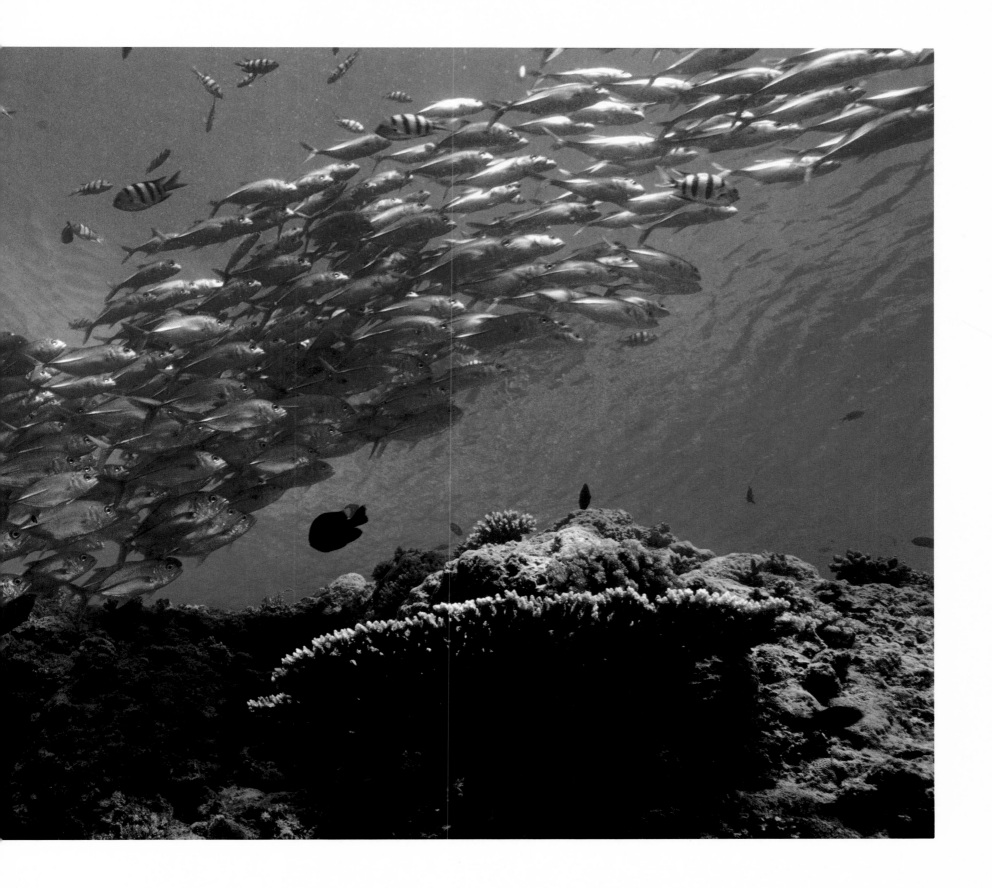

Despite their bad reputations, most morays are actually shy creatures who prefer to remain hidden in their holes or, as in this image, behind the protective spines of a sea urchin.

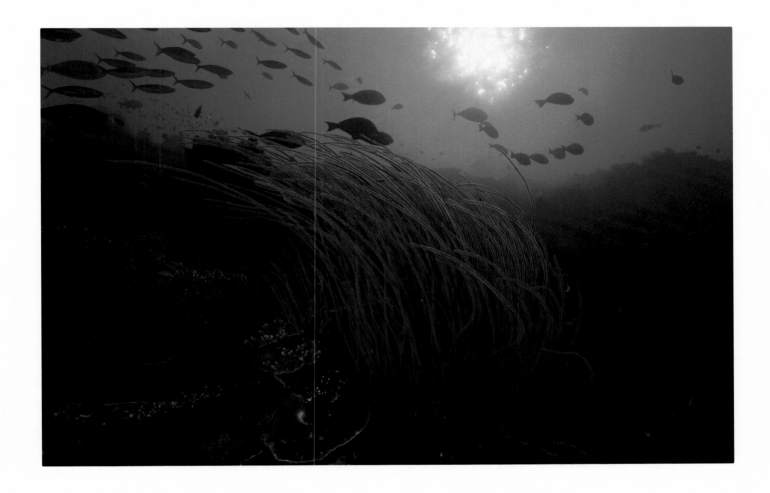

The flexible branches of sea whips indicate the direction of the strong currents. Great clouds of reef fish
swim straight into these nutrient-laden flows to gorge themselves on plankton.

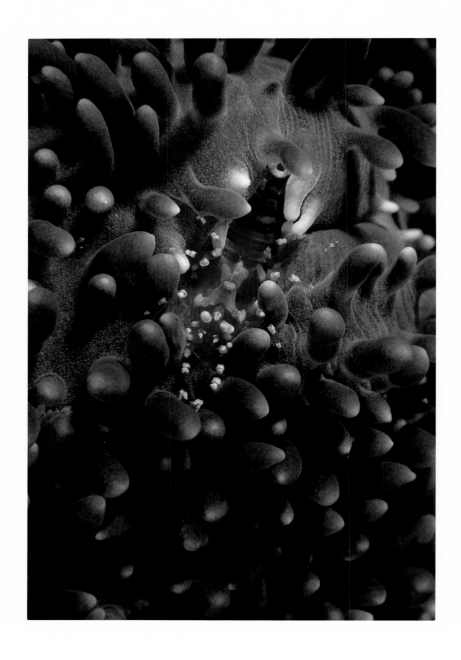

Shrimp in corallimorpharian mouth

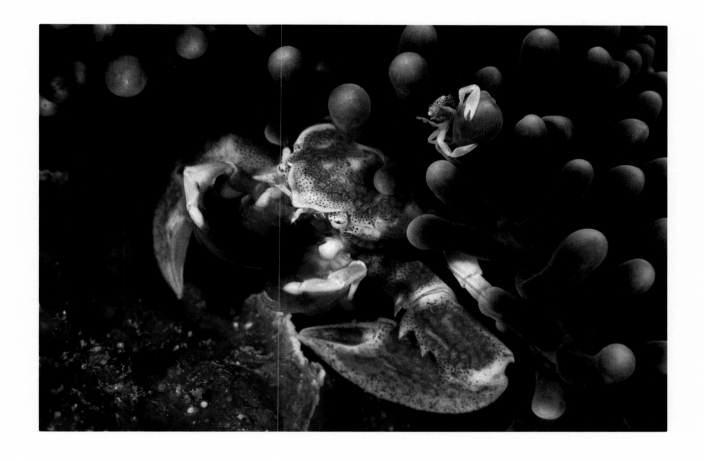

Porcelain crab and juvenile

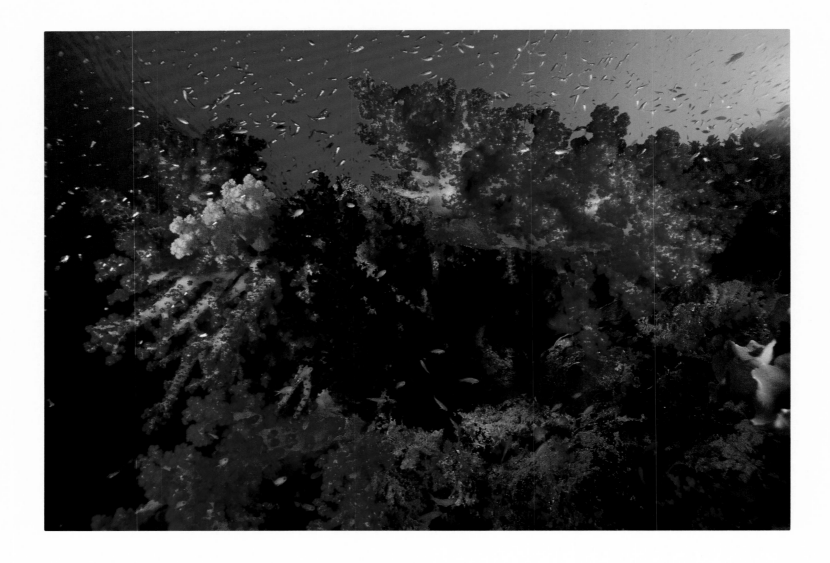

Soft coral

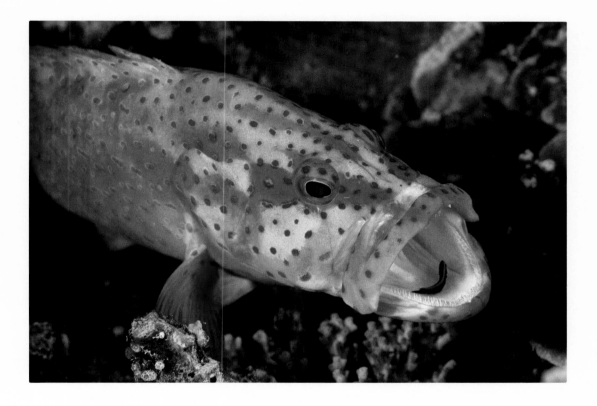

Coral trout with cleaner wrasse ■ Cleaner fish operate from stations near prominent coral heads
and advertise their readiness to clean by dancing above the coral. Meticulously grooming their
clients from head to tail, the small cleaners eat bits of dead or diseased skin, parasites,
and bacteria.  In other circumstances, the cleaner might be prey for the larger fish,
but here, for the benefit of both, they temporarily abandon their usual roles.

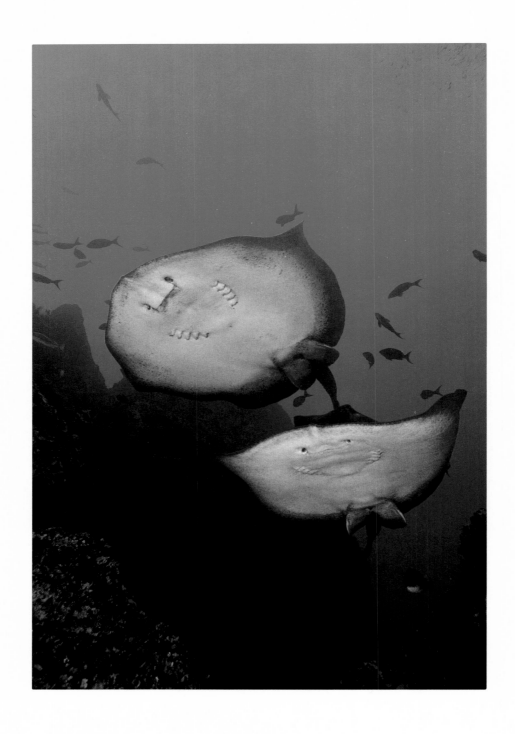

Marbled rays

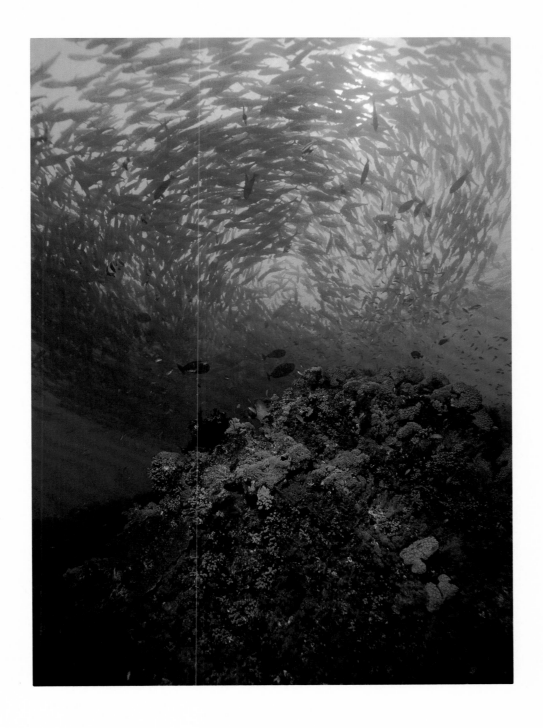

Schooling jacks

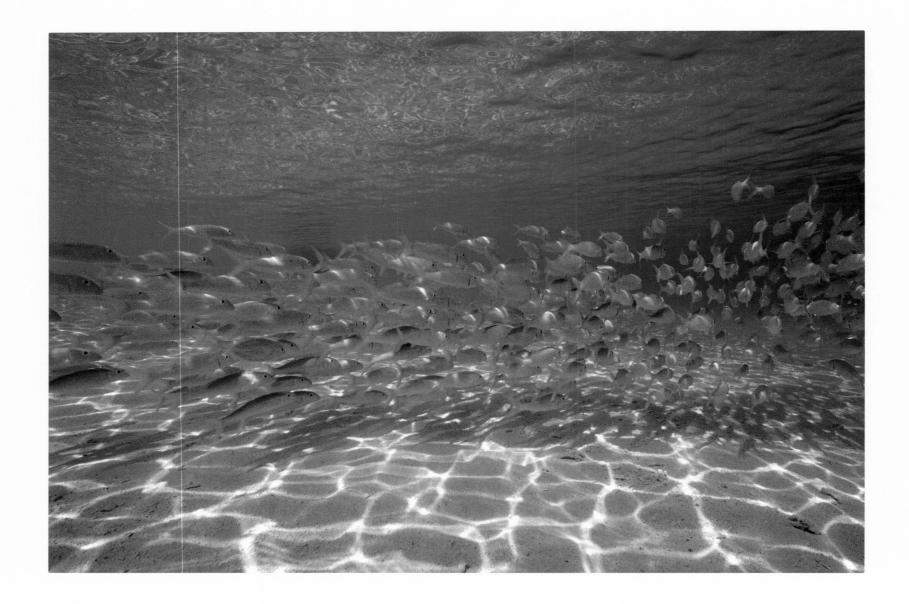

Goatfish over sand flats

# A Sea of Sand

**Rectangles of sunlight** flash like beckoning signal mirrors and guide us away from shore across the sculpted sand bottom of the sea. Our unanswered questions about life in the underwater world have brought us to an apparently barren place: miles and miles of stark white sand flats wrapped around a tiny Indonesian island that is tucked far away in the vast reaches of the western Pacific.

As our fins gently graze the parallel symmetry of the sand so patiently wrought by wind and waves, we look back so that we can visualize our way home across this featureless expanse.

Small puffs of sand rising outside our wake are **our first clues that these sand flats are more than voids**, more than deserts to be crossed over on our journey to the distant reef.

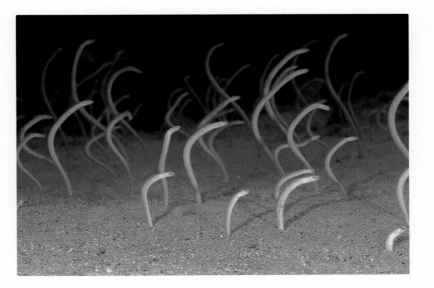

We glance up quickly and see a cluster of spotted garden eels sinking into concealed burrows. If we move toward them, they disappear completely. But if we stay at a respectful distance, the eels emerge from their holes and begin to browse cautiously in the gentle current. Midway between us and the eels, a speckled flounder hovers, then skims along the bottom with the horizontal motion of a science fiction starship. After it descends again we cannot distinguish the fish from its sandy landing pad.

Hours of intense, intimate scrutiny turn into days and nights as we explore the dynamic adaptations that shape the lives of the sand's creatures. Slowly we begin to understand that hiding is one of the common threads woven among the life that inhabits this place and that to comprehend its faint but crucial design we will have to open our minds as well as our eyes.

Before we came to the island, we had been told that we might encounter a curious animal, the gold-spectacled jawfish, which is endemic to Indonesia. This slim, two-toned fish, only four inches long, has a colossal head and luminous gold-rimmed eyes that never seem to blink. Like garden eels, jawfish are vertically oriented burrowing fish, maddeningly eager to withdraw into the sand at the first hint of danger. We discover that we can watch them only from a distance. Moving any closer than ten feet threatens the fish, and they retreat tail-down into the sand and vanish in an instant.

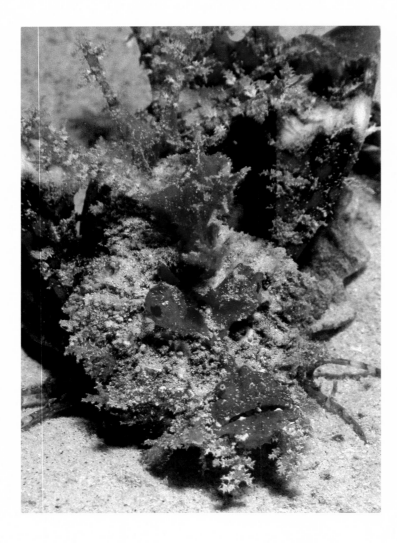

Close by our jawfish observation post, a clump of octocoral anchored in the sand sways back and forth even though the sea is still. Two orange eyes and a downturned mouth protrude from the sand. As our eyes meet the creature's, it flips a forehead topknot that looks remarkably like the brownish octocoral we had first taken it to be. We wave away the sand carefully, and a horrific-looking scorpionfish appears, its skin darkening with anger at this intrusion. Within a few seconds, the fish rises up to its full size and "walks" a short distance away, using its forked pectoral fins as feet. Collapsing, it lightens its skin and melts into the sand, rendering itself invisible once again.

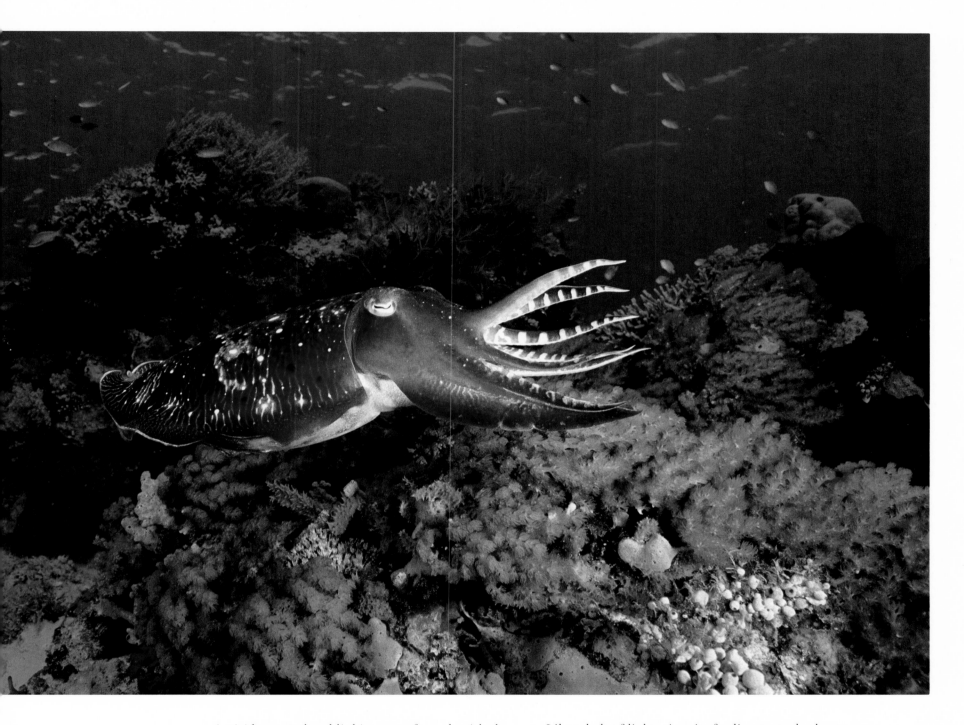

An iridescent glow blinking out of synch with the sunbeams catches our attention. We squint through the light until we discern a large cuttlefish, ablaze with incandescence, gliding toward us on the right. Lengthening its two outer tentacles, the cuttlefish maneuvers itself above and behind us.

Like a bolt of lightening, its feeding tentacle shoots out and zaps the jawfish closest to us. While sand dislodged by the cuttlefish's attack trickles down into the hole that once was the jawfish's home, we watch in stunned amazement as the cuttlefish backs away out of sight.

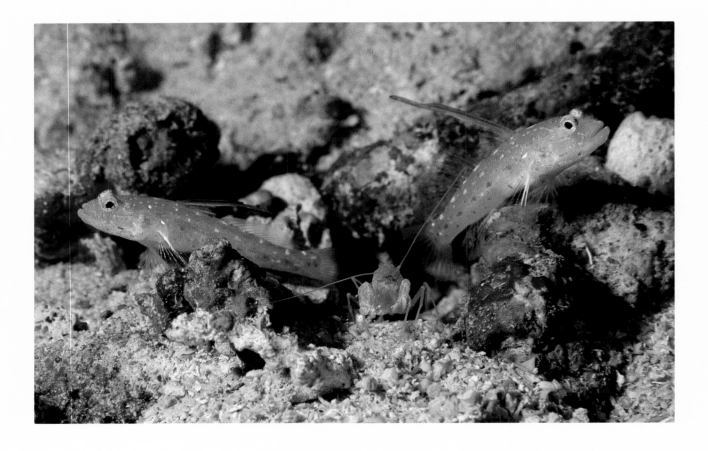

Pair of gobies with blind shrimp ■ Edward Abbey, who spent many years observing America's southwestern deserts, often remarked that appearances to the contrary, there are no vacant lots in nature. In order to see that which is not readily apparent, we must break old habits and learn to see anew. Discovering the life that resides in sand communities requires a bit of Abbey's philosophy of seeing. Sand flats are not bleak, featureless places, but rather showcases for the marvelous ingenuity of the creatures that make their homes there. These animals do not reveal their secrets easily. Time seemingly lost waiting for a shrimp to reappear from its burrow or searching for a flounder that has disappeared, melted into the sand, offers a good opportunity to discover the deeper layers of life in the sand community.

The specific behavior we are waiting so patiently to see is a male jawfish aerating a mouthful of fertilized eggs. Nature has charged the males of many marine species with the responsibility of caring for their unborn. "Pregnant" male seahorses gestate their young in frontal pouches, male anemonefish tend egg clutches laid on rocks beneath the skirts of their host anemone, and the jawfish, along with cardinalfish and a few other species, actually spend a week or more with their mouths filled to bursting with the next generation's sticky egg mass. Studying the marine science books we carried with us to this distant outpost, along with our mountains of photographic equipment and diving gear, we learn that the best time to see jawfish with eggs in their mouths is one week after the full moon. So until the moon waxes, we practice approaching the fish and hope that by the time the earth shadows its moon, we can hover within full-frame range.

Lying on our bellies in the sand brings us down to eye-level with some of the jawfish's neighbors, and we begin to observe them as well. Gradually we perceive a host of creatures whose secret for survival lies less in their shape and mobility than in their camouflage. As we scan the sand flats, bottom-dwelling fish materialize with excruciating slowness; trying to see the entire fish right away is an exercise in futility. We hope for a sign—a rotating eye or the flick of a fin to finish the puzzle. Without these subtle clues, there is little chance of being able to distinguish these animals from their background.

The skin of many bottom-dwelling fish is generously laced with cells called *chromatophores*, which are composed of concentrated batches of color pigments, and with glistening light-reflecting cells known as *iridocytes*. Many types of fish can change their color by expanding and contracting their chromatophores and iridocytes, but bottom-dwellers are more skillful than most. Whatever they lack as swimmers, they make up for as camouflage artists.

The full force of the noon sun scalds our backs and turns the sand flat into a rippling mirage without beginning or end. **There is an unseen artistry at work,** and it bestows a wealth of attributes in this mysterious place whose boundaries seem to stretch as far as the eye can see. Our eyes repeatedly probe the white plains and our minds **try to detect one more link in this realm's chain of existence.**

We focus our attention on another jawfish. He looks at us nervously as we dare to creep within six feet of him. It is a bold move, but we are rewarded with the sight of his gaping mouth filled with tiny transparent eggs. We can see that the fish is agitated and wants to dart back into his hole. But instinct prevails; his eggs need attention, and an extraordinary act unfolds. Rising a couple of inches farther out of his hole, the jawfish "coughs" out a mass of eggs. For a second they spin like crystals in the water, and then miraculously he sucks the precious globules back into his wide-stretched mouth.

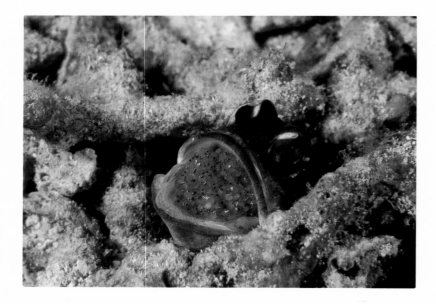

It is an impressive display of beauty, balance, and parental vigilance. The brief instant when the jaw-fish propelled his eggs out to roll and bathe in fresh sea water is the only time during the days-long gestation period when he doesn't have a mouthful. We can only wonder what evolutionary quirk relegated jawfish to the sand flats and then compelled them to brood eggs in their mouths. It is unknown how or when jawfish began mouth-brooding, and we can only speculate that these fish ingeniously invented this way to protect their eggs in this environment with its scarcity of safe havens.

We begin to look upon the sand flats as a distinct continent within the marine world, a continent with no apparent visible divides or geographic boundaries. As this environment is not sufficiently varied to provide separate niches for each species, the animals that live here have been forced to experiment with specialized physical forms and unique life cycles in order to survive and assure the success of future generations.

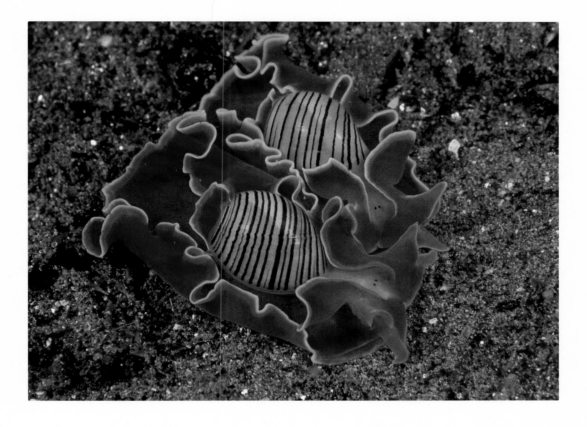

We have stayed in the water until well past dark, and as we swim back to shore, our lights flicker over a sandy bottom that sparkles like diamond dust. What looks like a speck of paper stuck in the sand rivets Burt's attention, and he waves me over to investigate. As we settle down to our knees, a pair of lavender bubble shells emerge from their daytime hideaways beneath the sand and twirl their voluminous mantles like flamenco dancers' skirts. Undulating across the bright stage created by our light beams, the bubble shells exit stage right and dance into the depths of the night beyond.

Long after midnight we sit on the beach digging our toes into the cool, damp sand. Sparkling galaxies of stars pierce the night and illuminate the dark sea. Even though we cannot see it, we know that there is an astonishing oasis beneath the sand flats, **a repository of life more magnificent and far more complex** than any reality **we could ever imagine.**

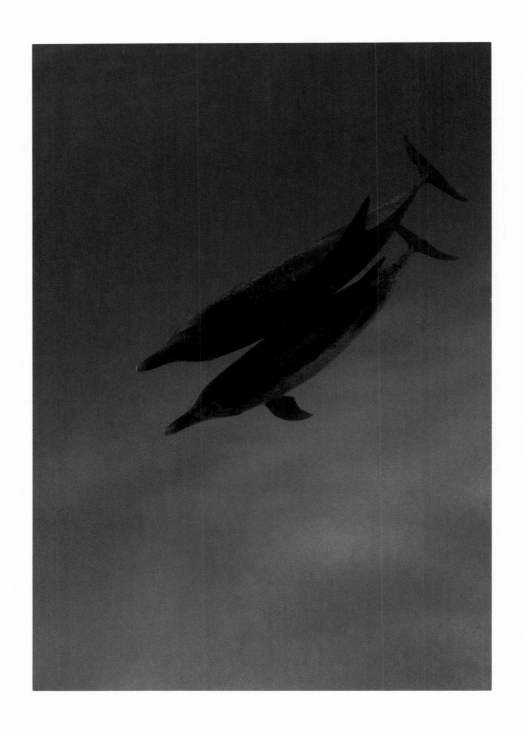

Atlantic spotted dolphins

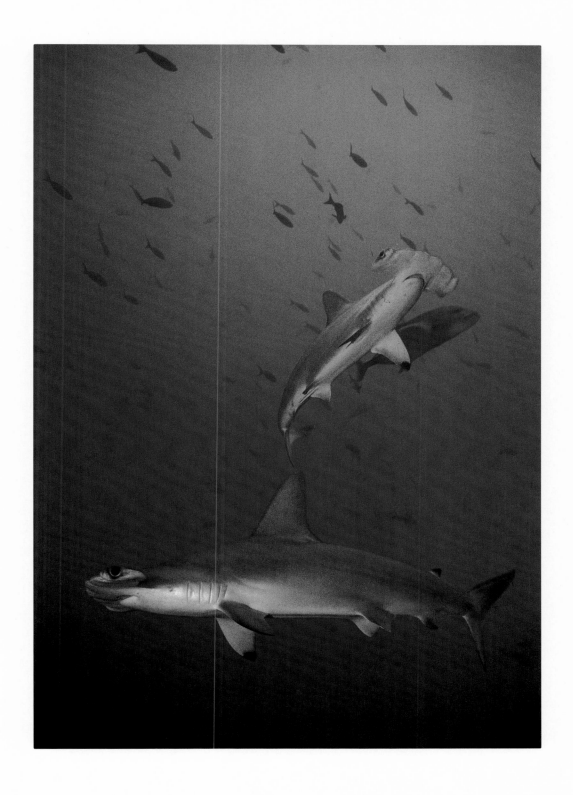

Scalloped hammerhead sharks

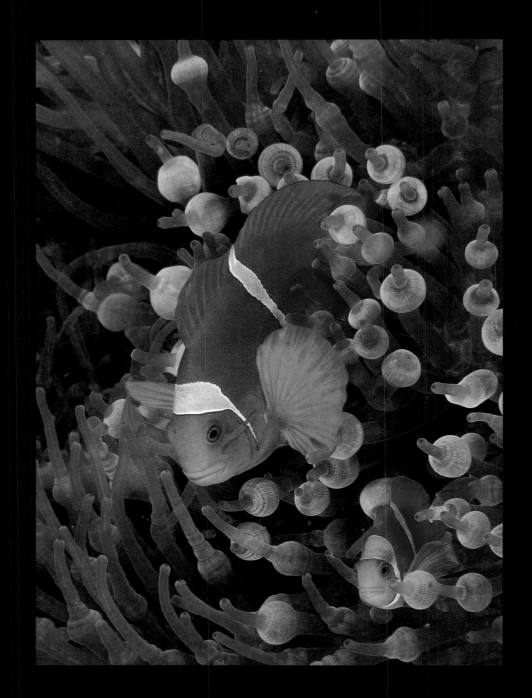

Spinecheek anemonefish

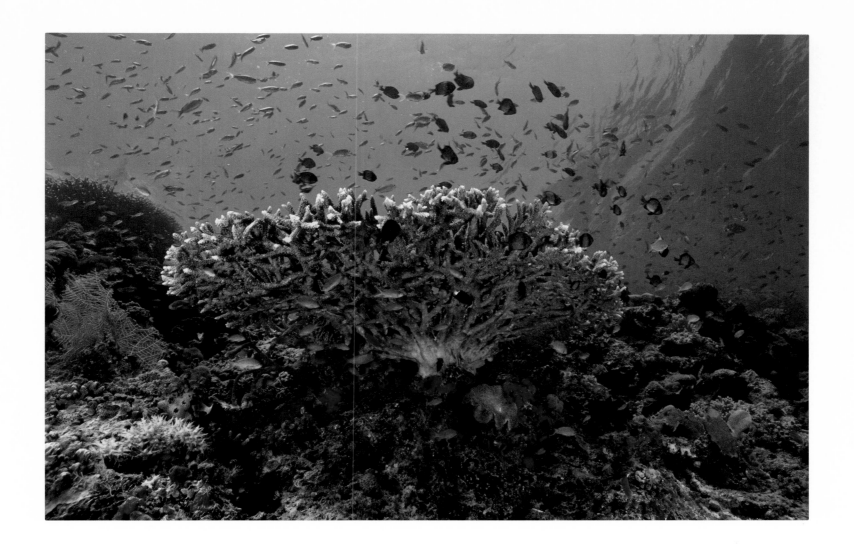

Table coral with anthias

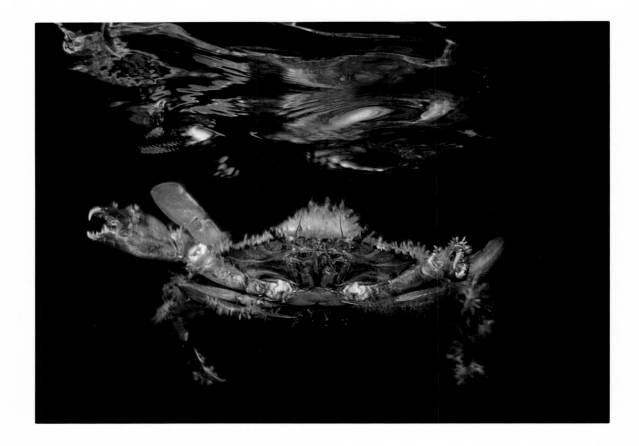

Swimming crab with hydroids ▪ The hydroids help conceal the crab from predators, and the crab serves as a mobile home for the hydroids, dragging the filter-feeding invertebrates on its journey through the sea.

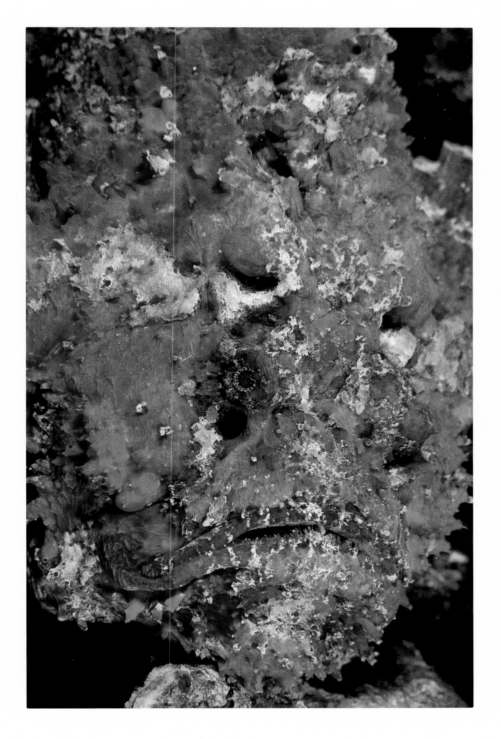

Stonefish

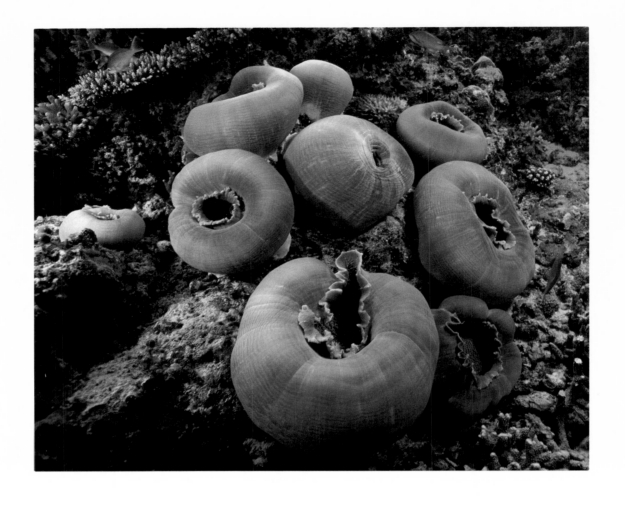

Corallimorpharians

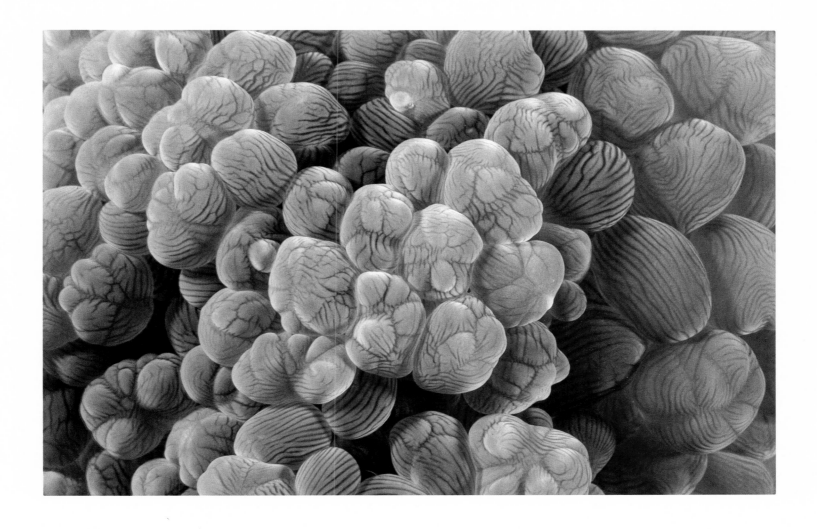

Bubble coral

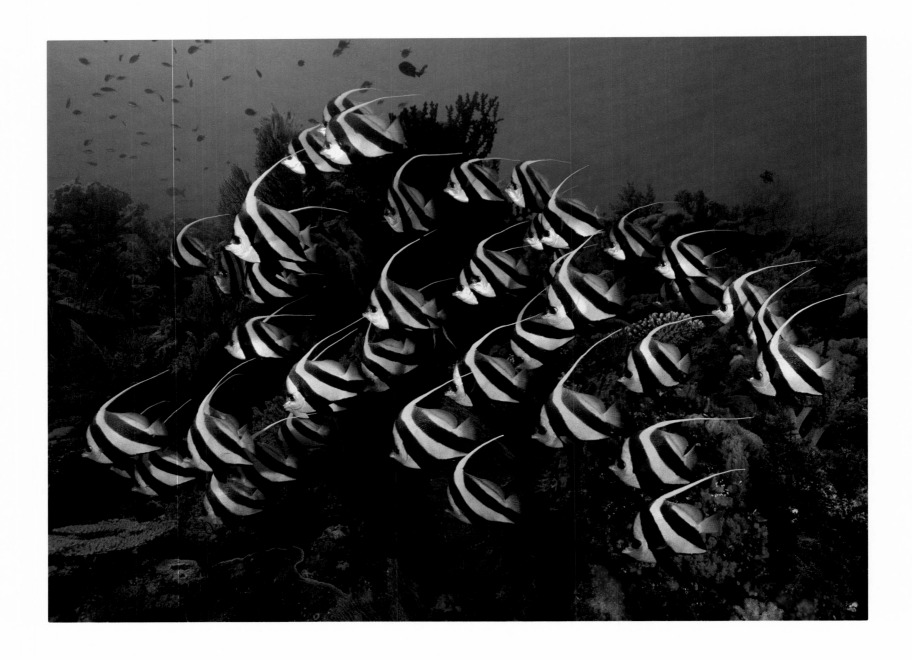

School of bannerfish

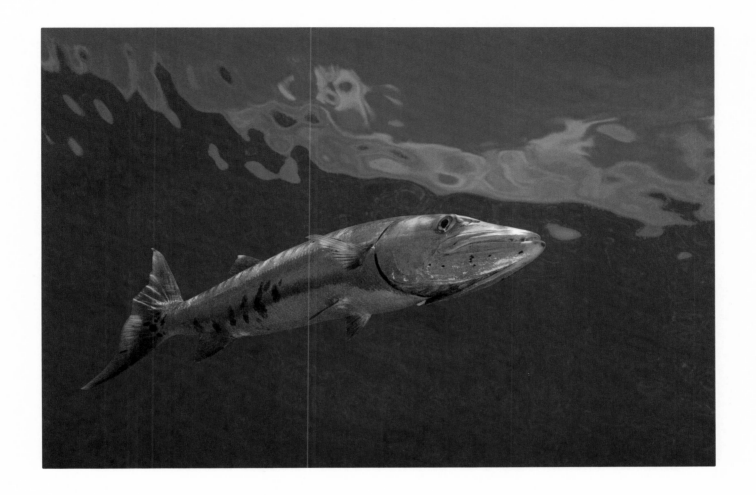

Great barracuda

# The Inner Sea

Slipping and sinking, we trudge through **ankle-deep
black mud oozing from a dim forest trail**
that leads to an inland lake, a watery doughnut hole,
in the center of this equatorial island.

A tangle of branches obstructs our view, and we gingerly poke our arms through them to
clear a spot for our equipment. Waving away the mosquitoes and flies, then shading
our eyes with our hands, we gaze through the opening to survey this alien place.

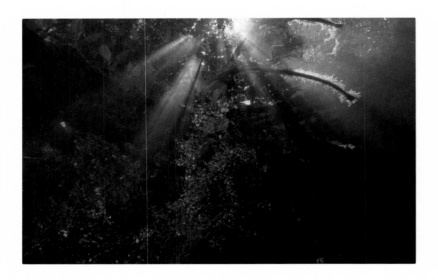

A wide band of mangrove trees rooted in inky water
forms an elaborate maze ringing the entire lake.
Carpeting the still surface close to shore, a lime green
mat of intertwined plants traps floating vegetation.
Beneath the plants, tiny silver fish nip at roots and
fallen leaves. Heaving on our diving equipment, we
push our housed cameras and strobes to the water's
edge and slide into this unknown world.

We have searched reefs and explored sand flats, and
now we are drawn to this half dry, half wet, half salt,
half fresh watery realm where life originates; where
evolutionary paths diverge, spawning organisms that
spurn the protection of the mangrove and crawl out
onto dry land, or drift into the blue to become a part of
the profusion of life in the sea. Now we turn inward to
hunt in this dank birthing chamber, the meeting place
between ocean and land, for the incipient designs of
the secret sea.

Once we are submerged we are fascinated with the fetid realm of the mangrove roots. The stilt-like props are heaped with invertebrate growth as profuse and complex as anything we have ever encountered on the reef. Scavenging crustaceans comb the roots feeding on decaying material. Abundant on the outer reefs, *Halimeda*, a green alga that functions much like hard corals, manufactures calcium to strengthen its skeleton, and hangs in long pastel green streamers from the mangrove roots. Beaked fish and a white-banded snake hide behind the algae curtains and nibble at unseen organisms. In the middle of the lake where the surface is clear of plants and sunlight dapples the bottom, another type of *Halimeda* grows like a lush green pasture. When the *Halimeda* dies, its calcareous skeletons disintegrate into powdery sediments that form a rich substrate for foragers. This lake is a fecund place, teeming with the primeval biological processes that are the lush underpinnings of all marine life. We can easily see how the lake's cycle of life is, in many aspects, a mirror of life on the reef. The community of plants and animals flourishing beneath the algae feed and gain sustenance from each other as do the creatures of the reef.

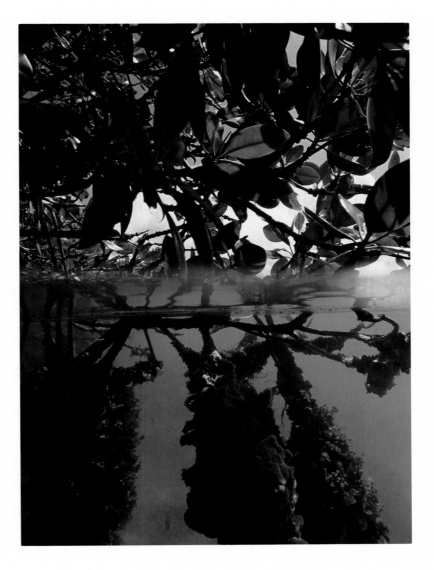

A thin beam of light rising from the fields of algae attracts our attention. Seeking the source, we swim over a narrow opening that slices through the limestone substrate and ends in an elliptical porthole to the sea. We speculate that this mysterious cut, chiseled during a period of ancient geological disturbances, must be the channel through which life, gestated in the swampy lake, is transported to the open sea. The lowering tide allows us to float through the tunnel and out into water that is deep, blue, and clear; where the range of visibility stretches far beyond that of the murky green waters of the lake. Surprisingly, there is no reef here—just barren volcanic rock and a featureless expanse of open water.

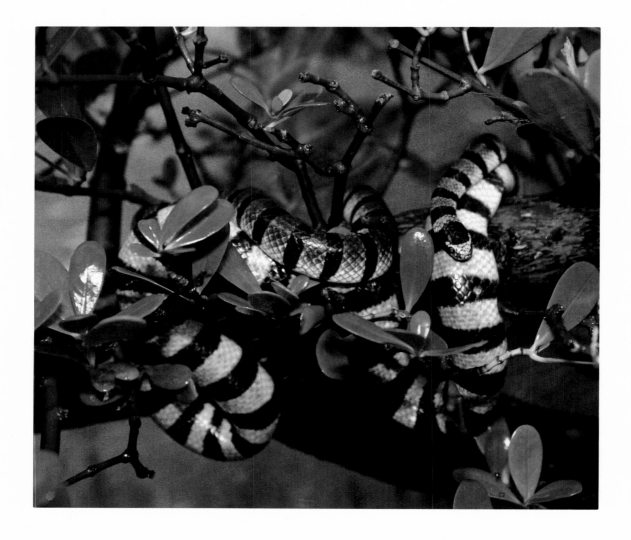

Travelers between two worlds, air-breathing, sea-dwelling banded sea kraits rest in mangrove trees.

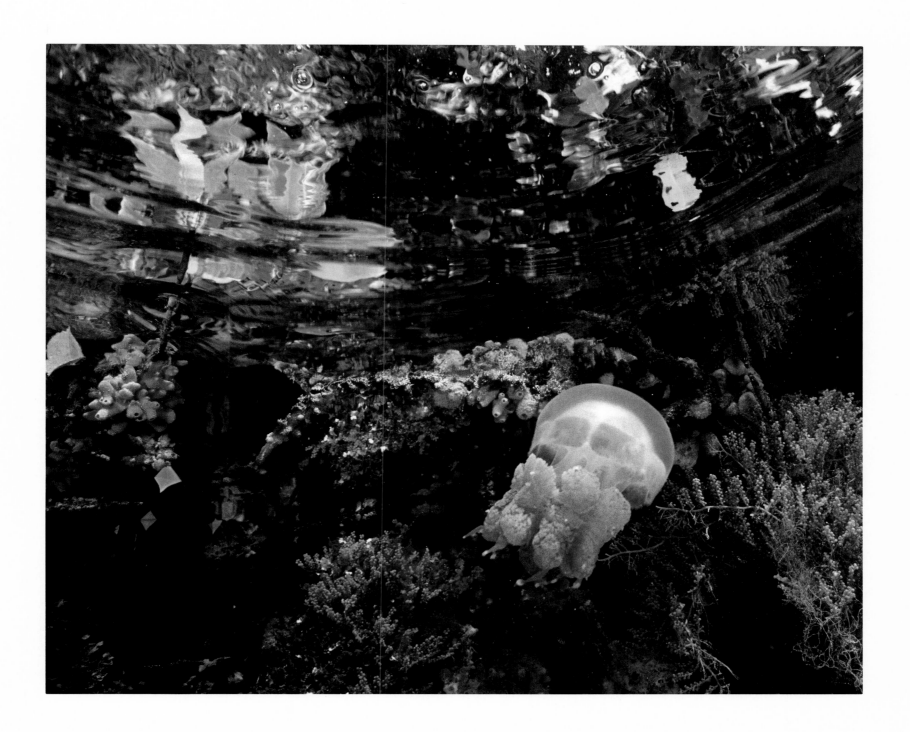

Mangroves with jellyfish ▪ Thriving in brackish water and surrounded by a profusion of life, mangrove trees sustain ancient links between land and sea.

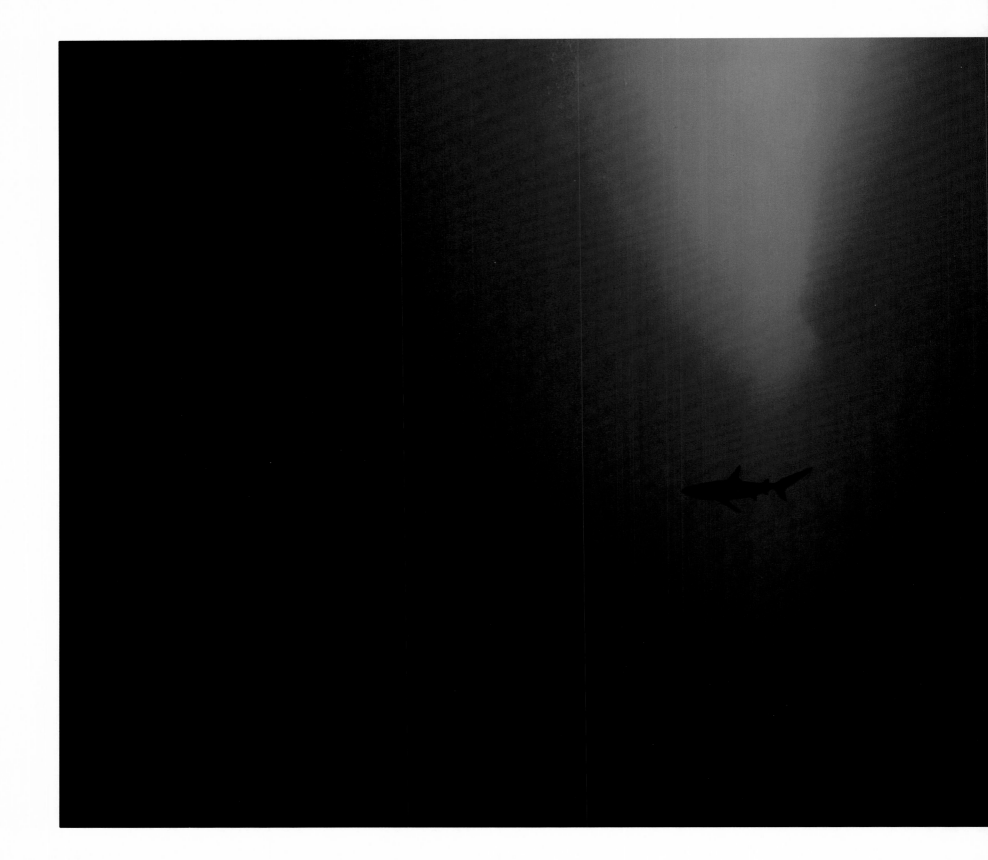

We have spent most of our adult lives documenting the sea, hoping that a secret would be revealed to us, a mystery would be solved, a design would come into focus, and two pilgrim souls would be at peace. But at this moment, we do not feel at peace. We desperately want to solve the puzzle. It seems, however, that the clues are becoming harder and harder to uncover. The sea appears empty, yet we know that it is filled with urgent life. We feel isolated and intrusive, and unable to connect to the dynamic forces pulsing around us.

Defeated, we decide to retreat to the lake's dark womb. As we begin our ascent, looking up to find the entrance to the tunnel, Burt turns to face the open water one final time. A second later, he grabs my shoulder and spins me around. In this instant we realize where we are: suspended in a slender knife of sea water within a submarine fissure. It feels eerily, inexplicably surreal. A shark, a gray whaler, framed by the parallel walls of the crevice, cruises in the transparent blue distance. In stark solitude, it soars above us with a dignity and confidence that transforms our disappointment into awe.

Burt reflexively lifts his camera and takes one frame. Confronted with such an extraordinary image, I expect him to continue photographing. Instead he lets the camera fall to his side, and the two of us hover, breathing slowly and quietly, releasing a steady trickle of bubbles, keeping our eyes fixed on the shark.

Did this episode last only seconds, or long minutes? It is hard to recall. As we watched the shark, the sea's energy seemed to flow through us, and we became simply fellow creatures in the ocean, with no errand more urgent than to share our mutual bond and to absorb the universal spirit of creation. Floating there, we began to understand that what we had been looking for all these years—a definable pattern, an all-inclusive design, a final world within world that we could capture in a photograph—could not exist as we imagined it.

The design we longed to discover was not perceptible to mere observers; it could be sensed only by the creatures living inside it.
**For a brief time in that volcanic crevice,** we were such creatures.

The alien world we had been pursuing became our own.
**The secret sea is within us.**

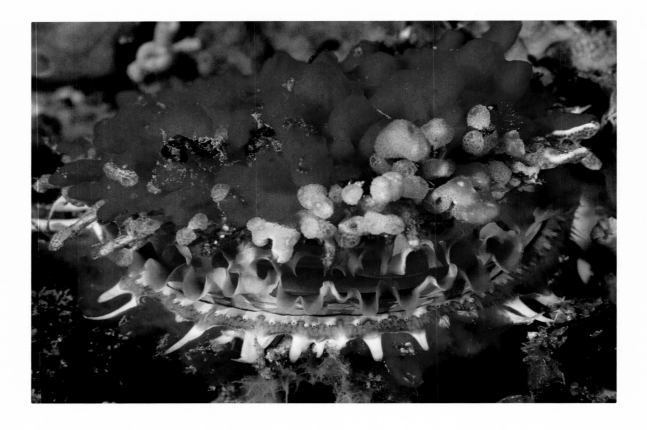

Thorny oyster ▪ A collection of tunicates and sponges have turned a thorny oyster's shell into a small mini-reef.  When the oyster draws water into its shell, its filter-feeding camouflage benefits from the surplus rush of nutrients.  The encrusting animals provide a living disguise that helps repel the oyster's natural predators.

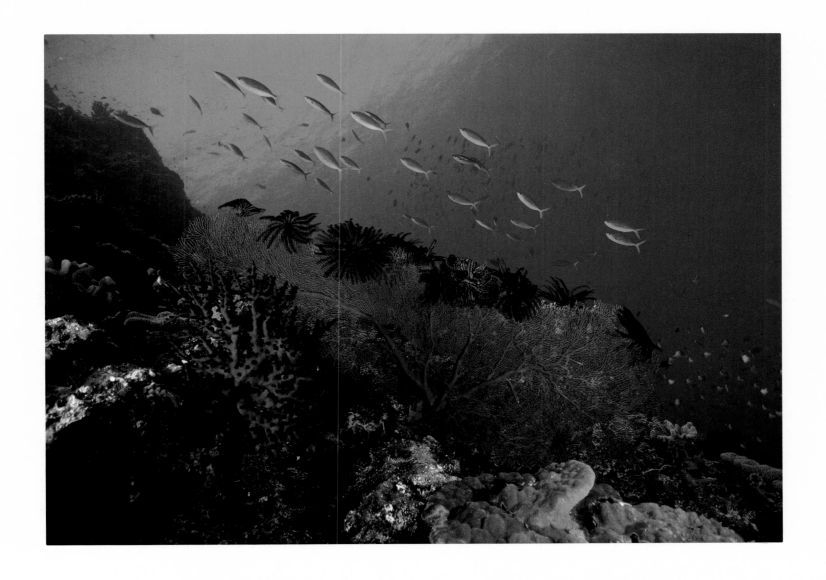

Crinoids embroidering a sea fan

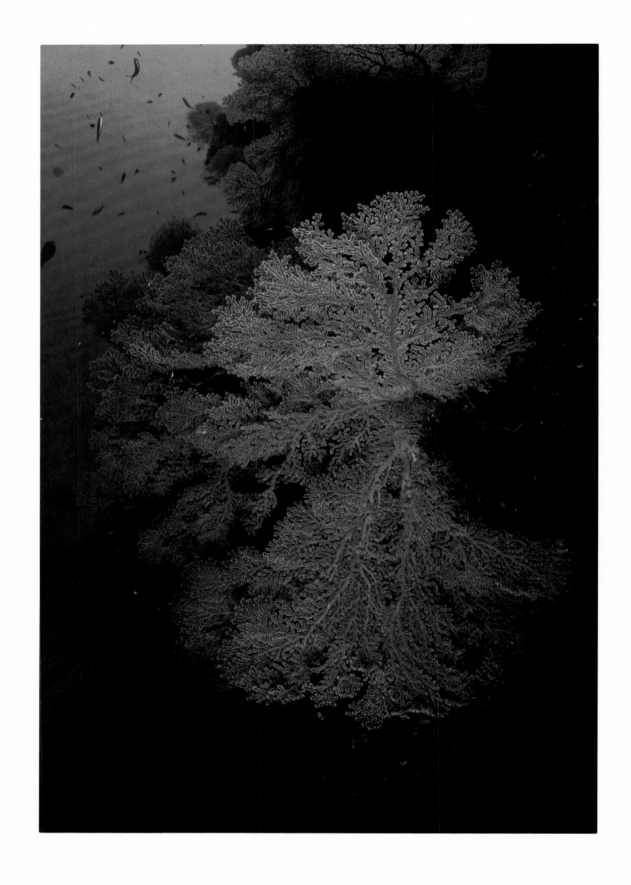

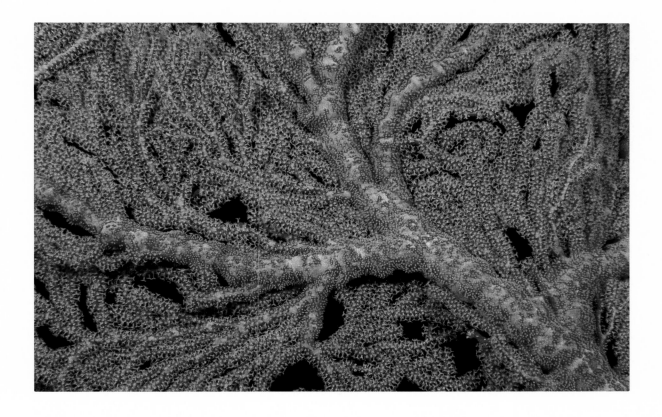

Sea fans stand tall in order to better capture the waves of planktonic organisms that travel with the currents. A fan's strong yet flexible skeleton provides a secure haven for numerous smaller plankton-feeding creatures.

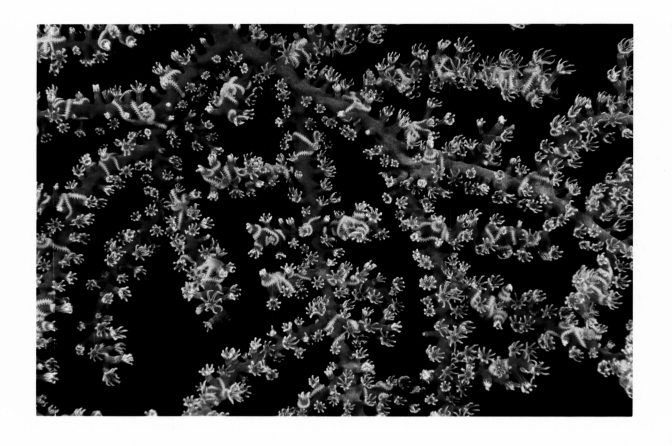

Brittlestars entwined in sea fan

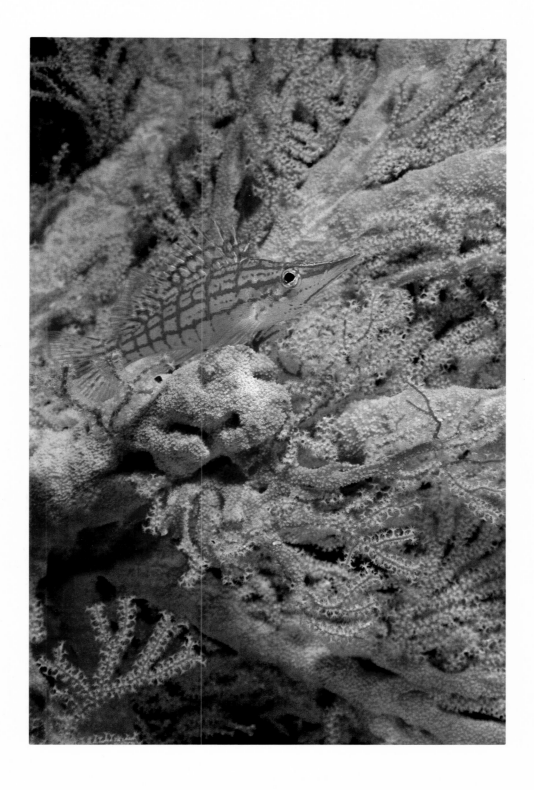

Hawkfish hunting among branches of a sea fan

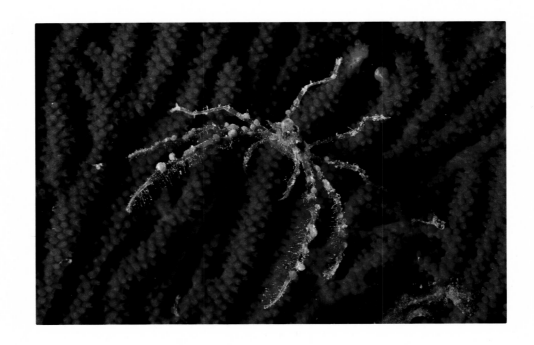

Unidentified decorator spider crab

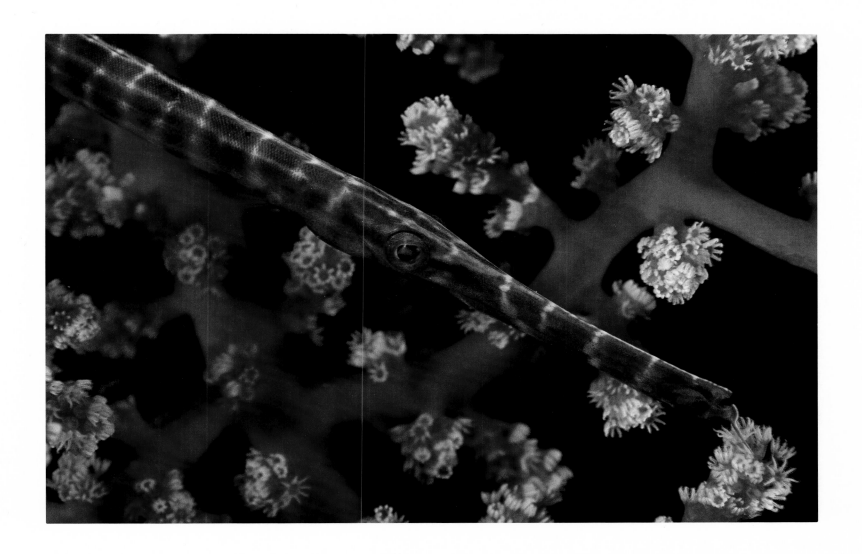

Trumpetfish

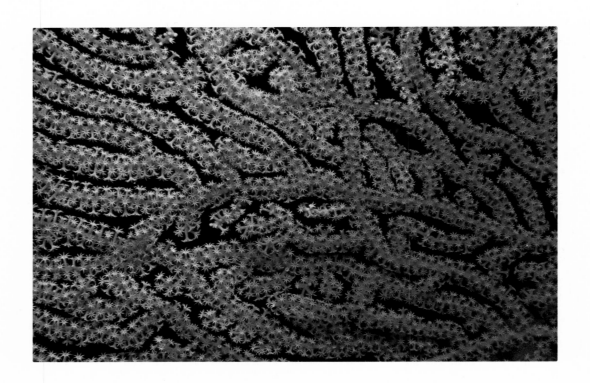

Variegated sea fan

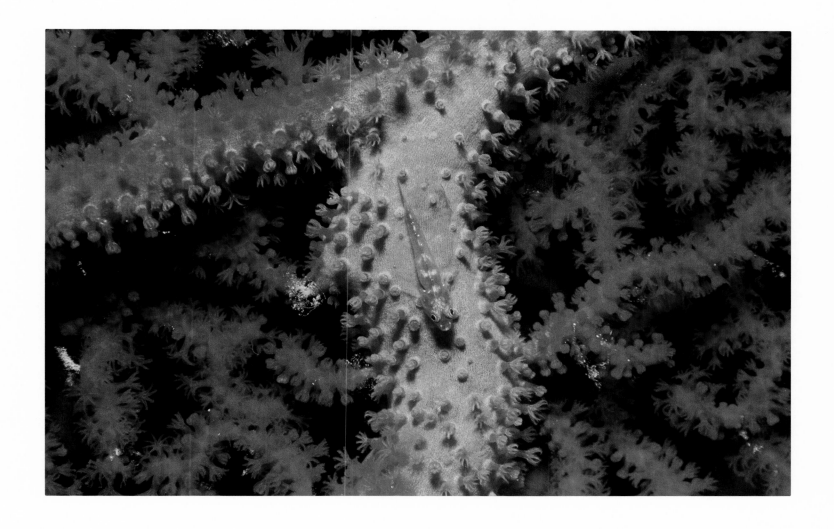

Goby on sea fan

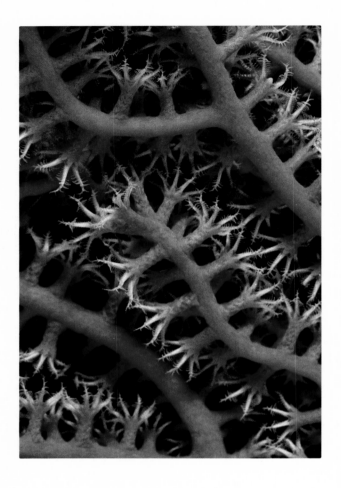

Sea fan polyps

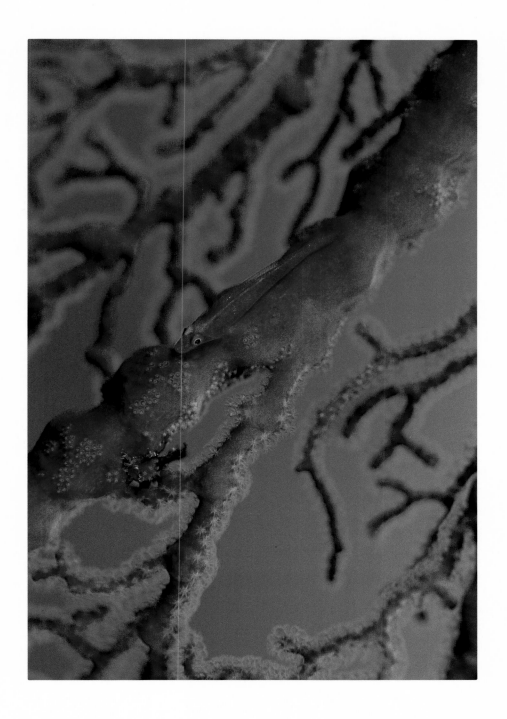

Camouflaged translucent goby

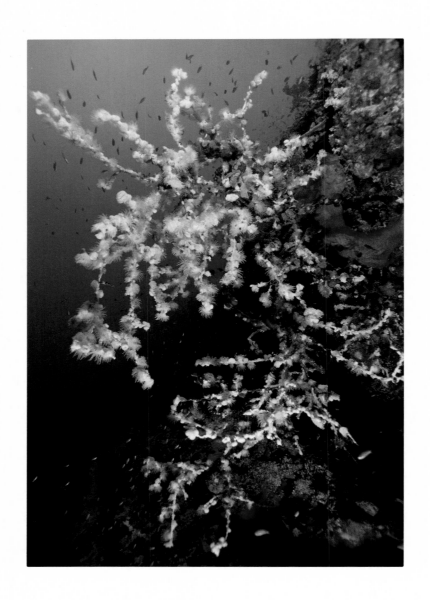

Sea fan skeleton encrusted with colonial anemones

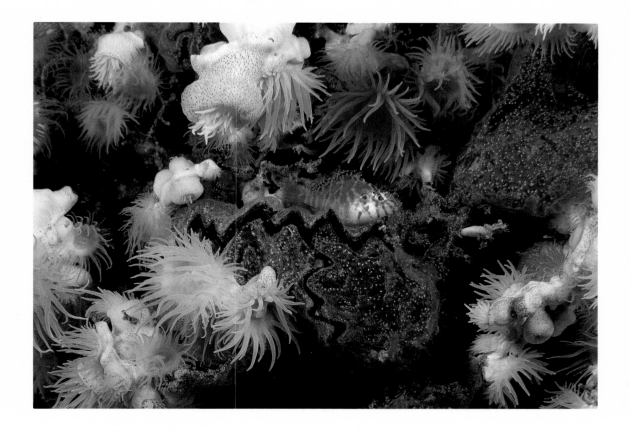

Even in death, a sea fan is sheathed with new life and provides refuge for
small animals that congregate among its branches.

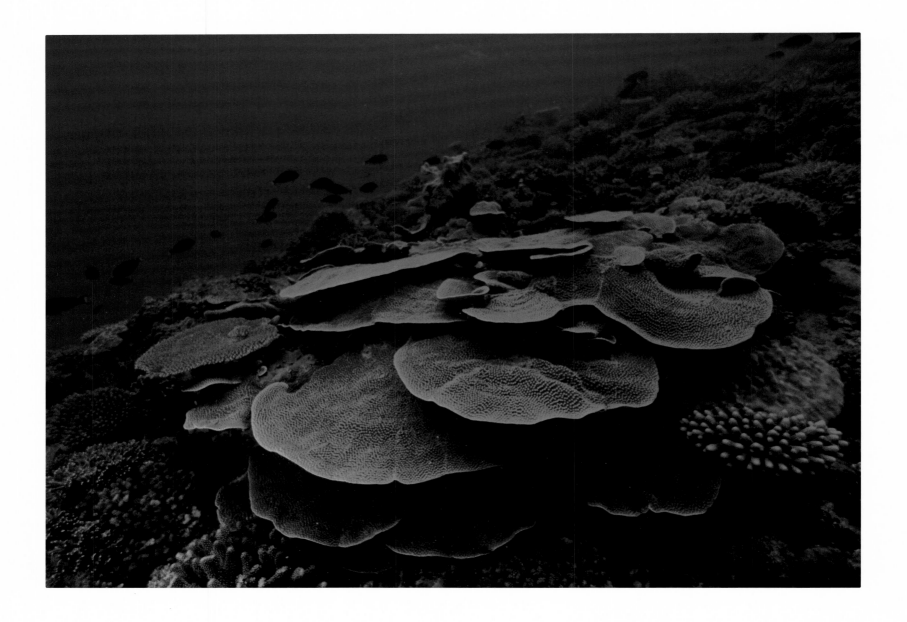

Hard corals are the foundation of the reef and provide the substrate upon which all other reef life flourishes. Individual polyps actually secrete their own cup-like limestone skeleton, and it is these skeletons, deposited by countless generations of coral polyps, that form the substrate of the reef. All of the polyps in the colony, though individual, are linked by the living tissue which covers the skeletons. Many hard corals, like this plate coral, also have a symbiotic relationship with a unicellular plant, an alga called *zooxanthellae*, which resides within the tissue of the polyps. As much as ninety-eight percent of the coral's nutritional needs can be provided by the surplus food that algae produce.

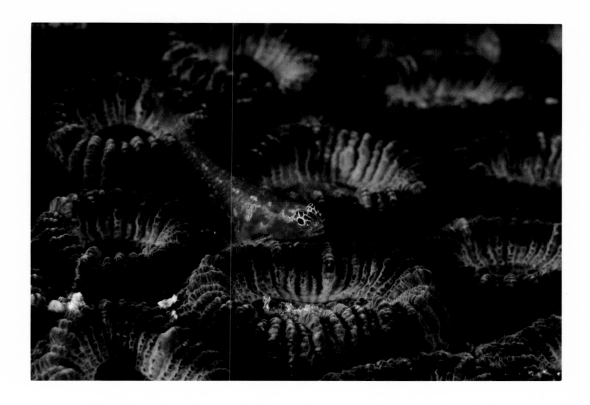

Like an astronaut displaced in an uncharted galaxy, a small goby scours the surface of a star coral colony looking for sustenance and shelter between the mountains and valleys of an alien land.

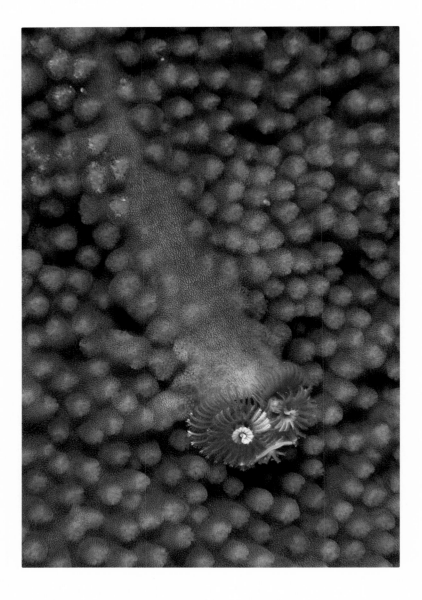

Although it looks as if the Christmas tree worm has bored into the coral, it actually has secreted its protective chamber at a rate commensurate with the coral's growth. Sensitive to light and pressure changes, the visible part of the worm, its feathery feeding apparatus, is able to withdraw quickly into its tube when disturbed.

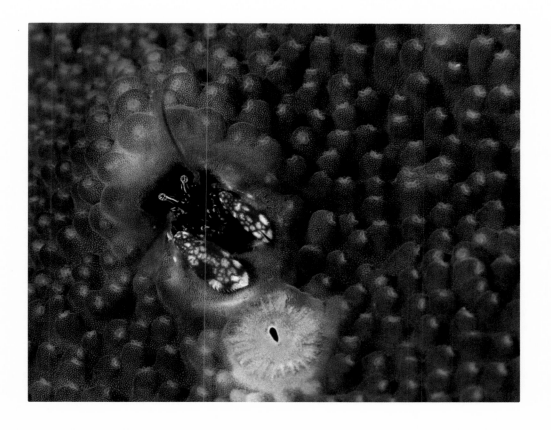

Space is never wasted on the reef. Hard corals often become menageries for other animals.
When holes are abandoned, new residents, like this hermit crab, are quick to move in.

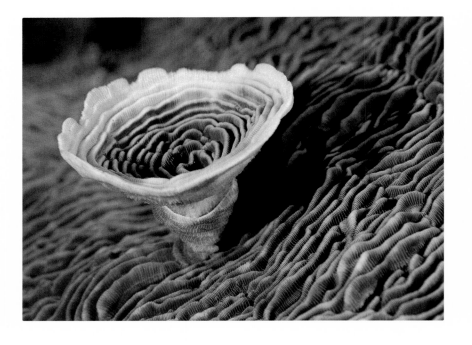

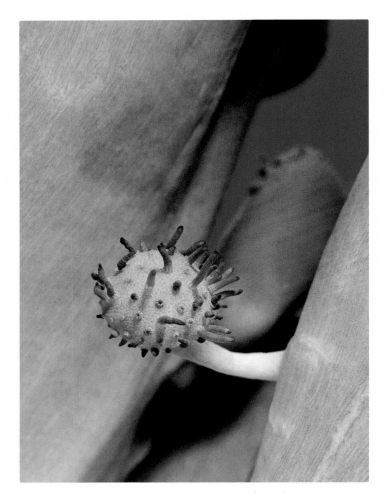

Budding corals ∎ To find adequate room to expand in extremely limited reef space, new generations of corals are sometimes cloned into aberrant forms.

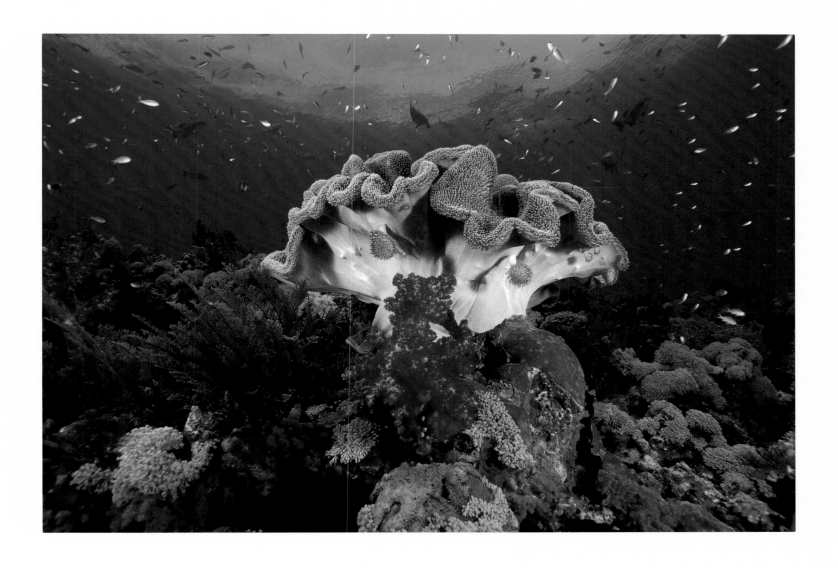

Leather coral showing budding

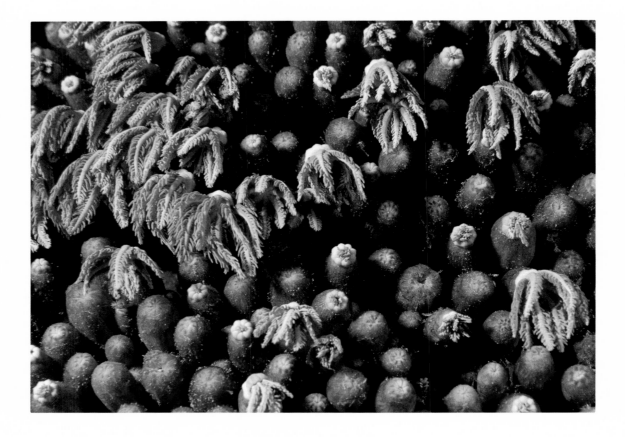

Partially opened octocoral ▪ Stimuli such as the time of day or the force of the currents signal the corals to extend their tentacled polyps to feed or, conversely, to retract into their calcium skeletons.

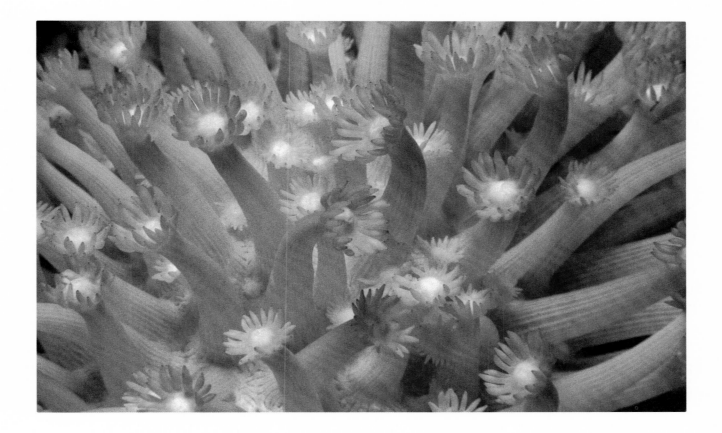

Feeding octocoral

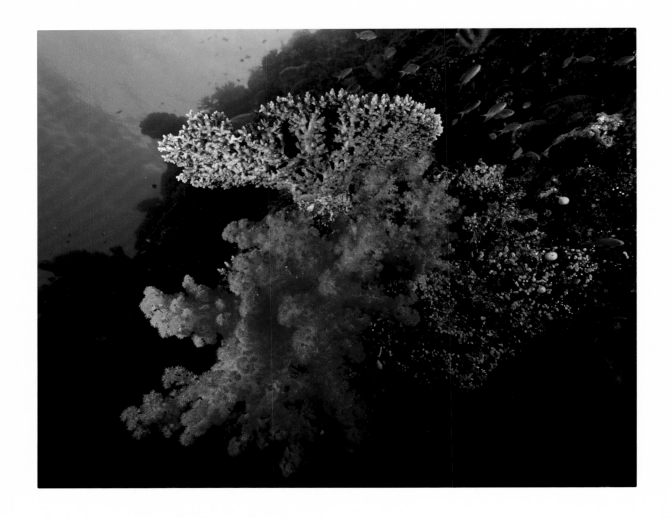

Many animals spend their entire lives in the world defined by the graceful branches of a soft coral colony and exploit the bounty of planktonic organisms caught by the coral's polyps.

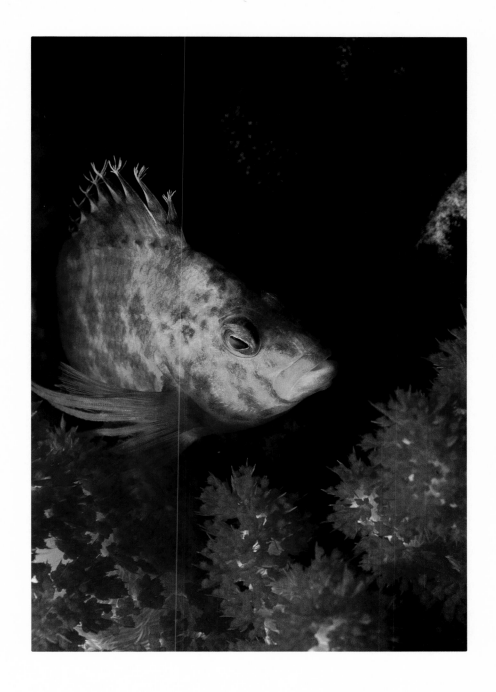

Golden hawkfish in soft coral

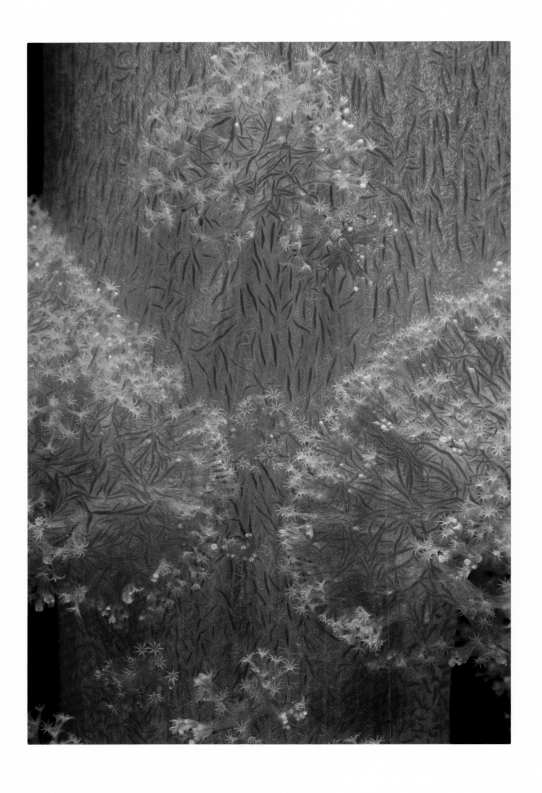

Soft coral "mirror image"

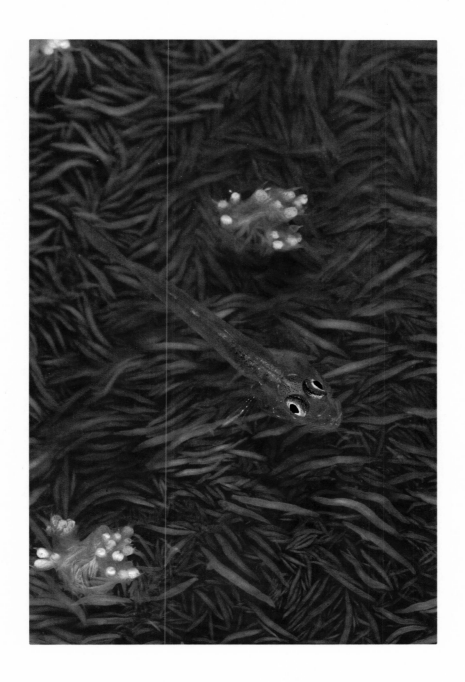

Many-host goby on soft coral

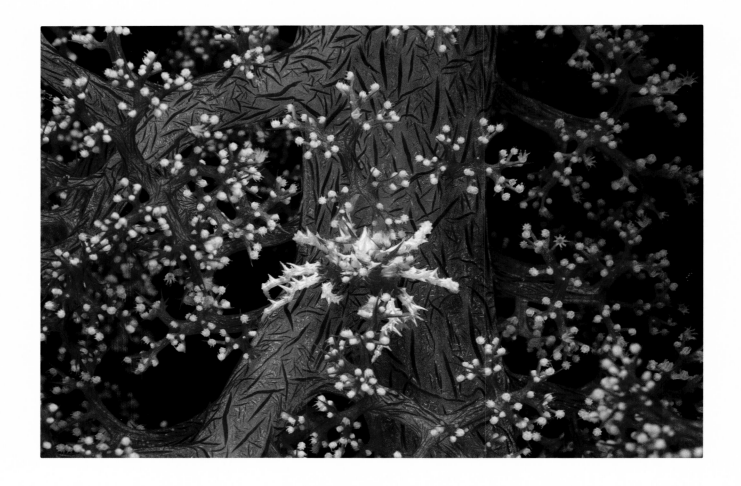

What appears to be a cluster of polyps is actually a tiny crab, no bigger than a thumbnail, wearing a disguise
made of living polyps and colored as radiantly as its soft coral host.

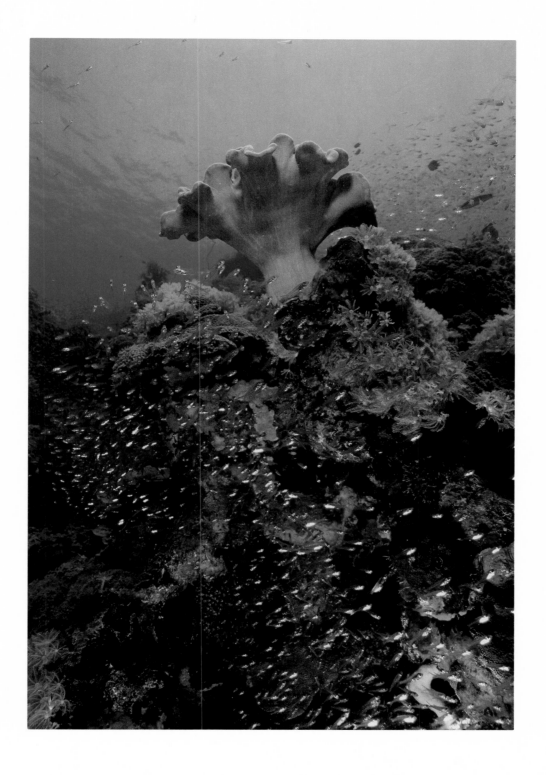

Leather coral

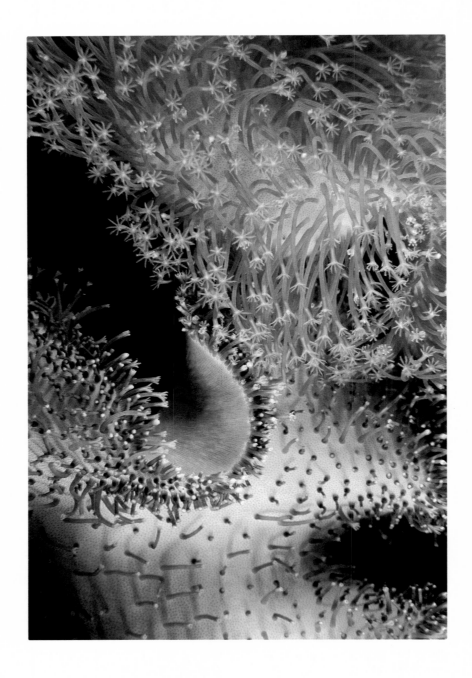

Leather coral is a true soft coral, having eight or a multiple of eight tentacles
on its polyps.  Six or multiples of six indicate a hard coral.
The tentacles of the soft coral polyps have tiny pinnae or
side branches, while those of hard coral are smooth.

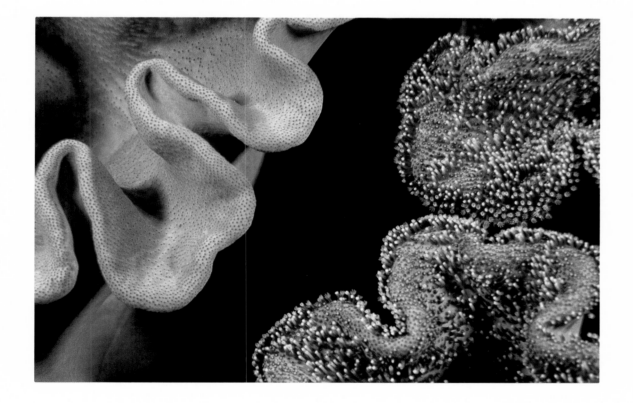

Two leather coral colonies, one with polyps open to feed

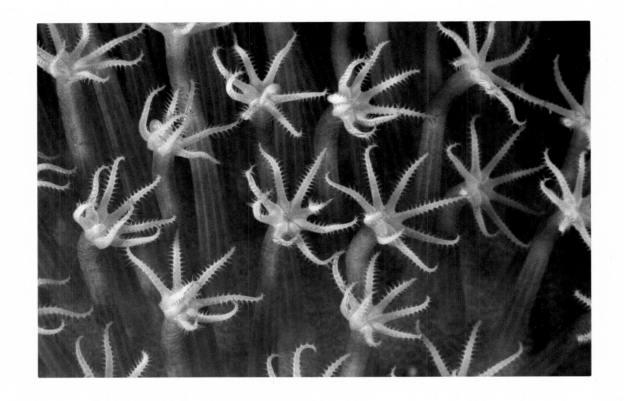

Feeding leather coral

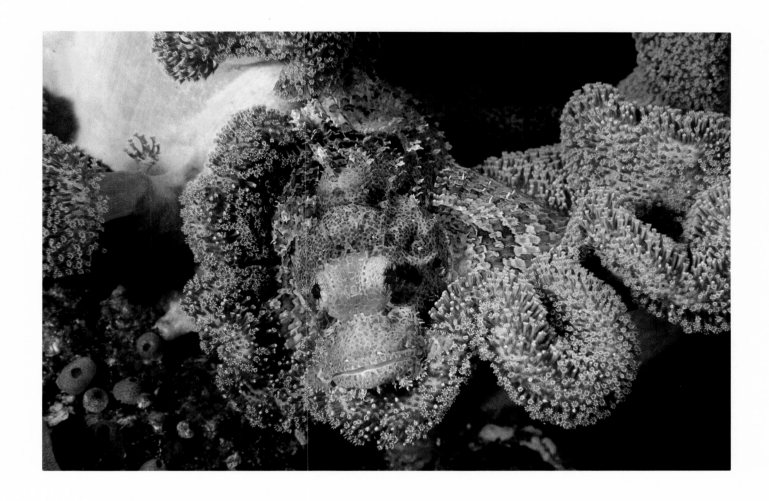

Scorpionfish nestled in leather coral

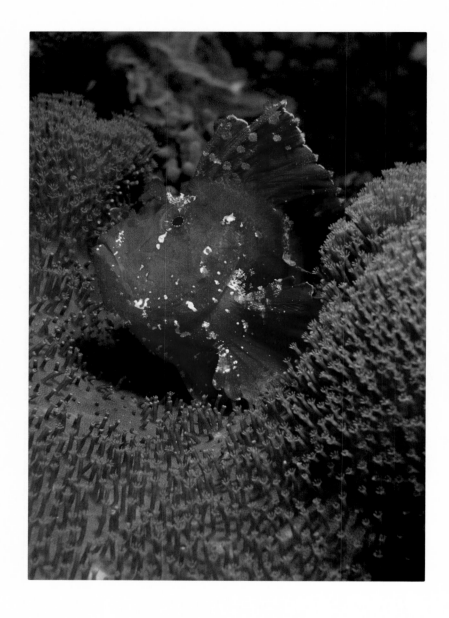

Leaf scorpionfish sheltered in leather coral

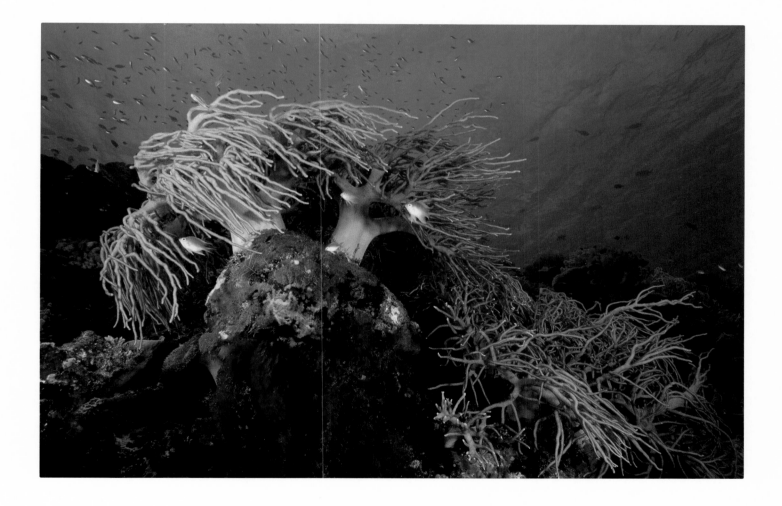

Soft corals of the genus *Sinularia* produce chemicals that prevent other marine life from attaching to their skin. Medical researchers are extracting substances from these corals that may be used in the future to fight against cancerous growths and other skin diseases.

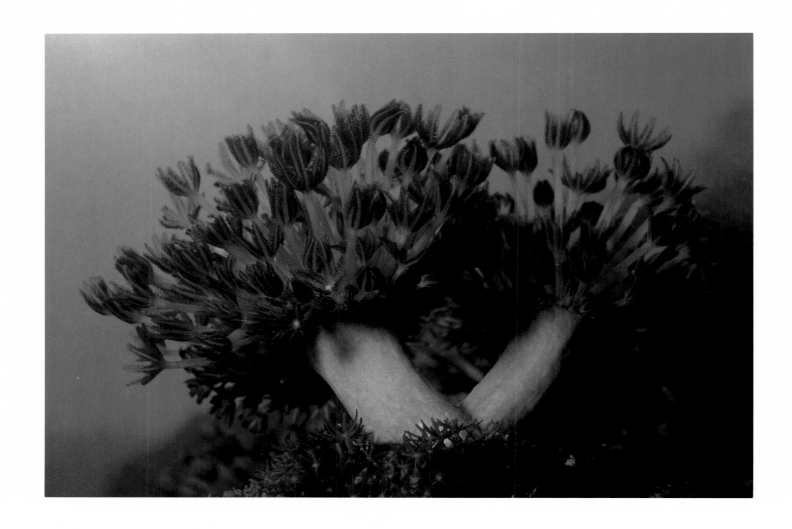

Flower coral colony ∎ These octocorals, like true soft corals, and leather corals, have tentacles trimmed with feathery extensions that maximize their filter-feeding efficiency.

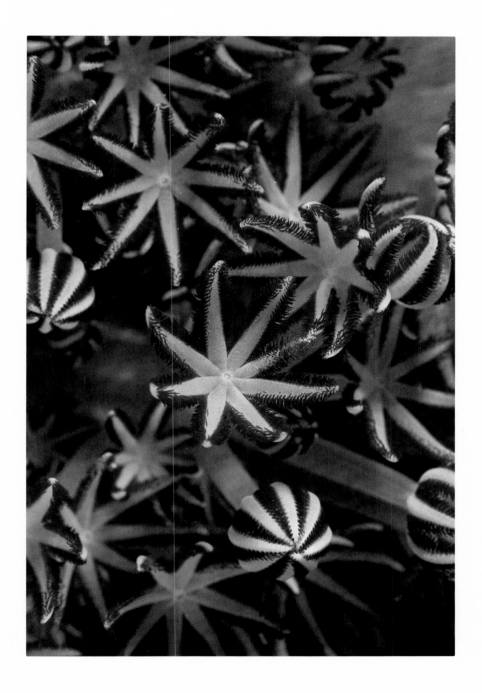

Flower coral polyps

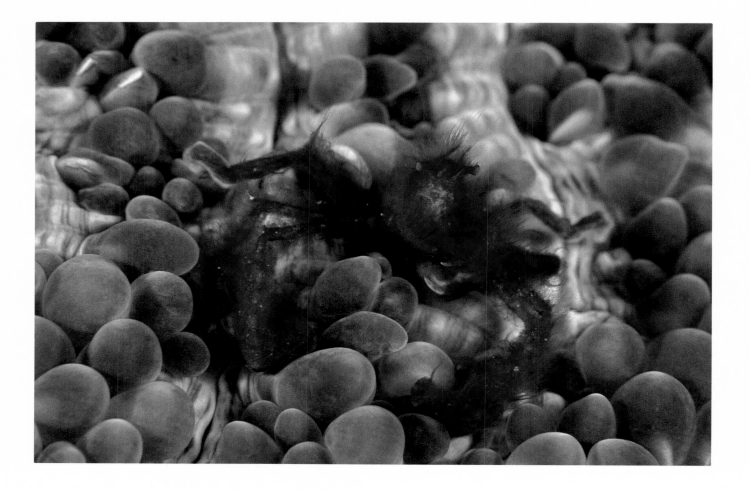

Orangutan crab on bubble coral ▪ Although bubble coral doesn't really look like a hard coral, it is classified with the stony corals because of its multiple of six tentacles and the physiognomy of its skeleton. Like all hard corals, bubble coral is covered by a protective layer of nutrient-rich mucus. It's the mucus that attracts a wide variety of scavengers and grazers like crabs and cleaner shrimp to forage on the bubble coral colony.

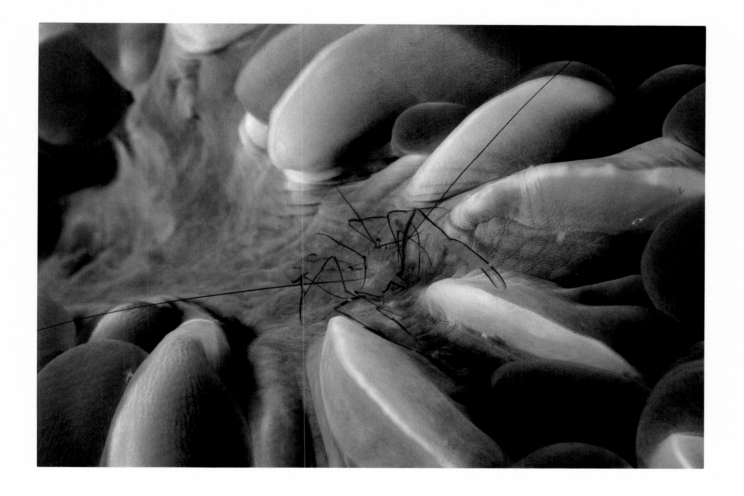

Cleaner shrimp on bubble coral

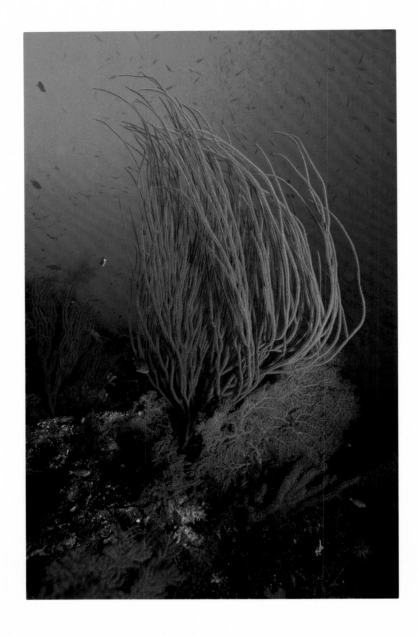

Individual pictures do not do justice to the cohesiveness between the animals that seek refuge in a sea whip colony. When photographs of a world within world like the sea whips are presented in series, then the grand design of matching life with life in the sea becomes apparent. Taking advantage of its shape, the trumpetfish pretends that it is a branch of the whip colony, and fits in quite well.

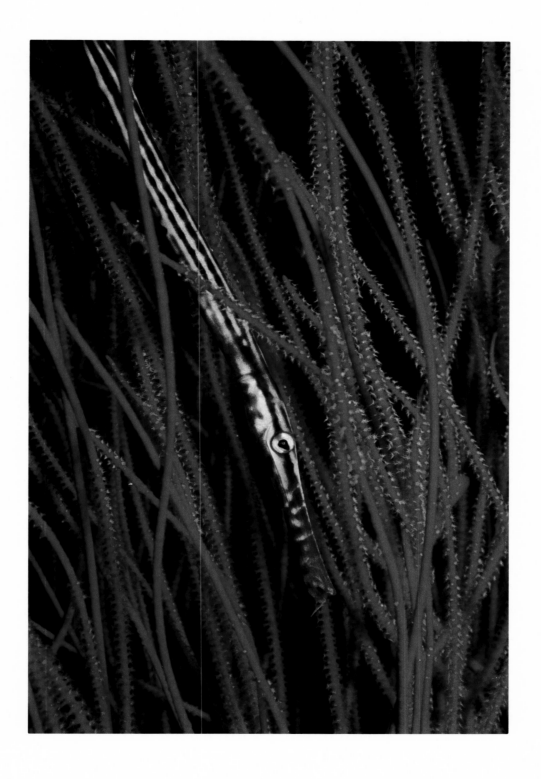

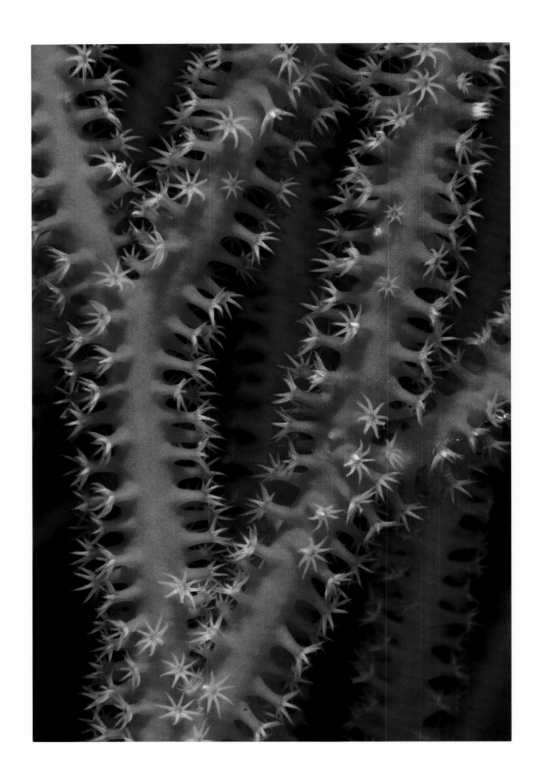

Sea whip polyps

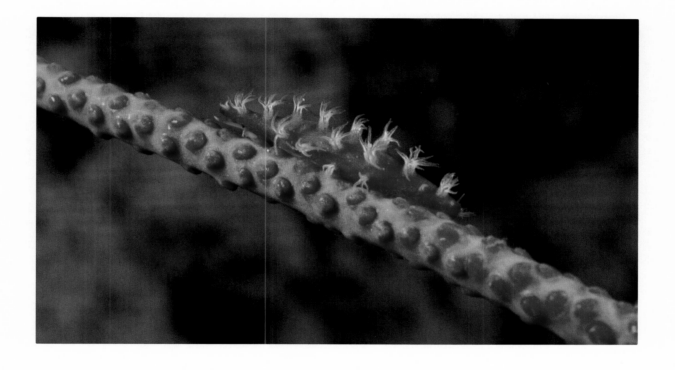

The spindle cowry's shape and color perfectly mimic its host. The slender mollusk even "plants"
sea whip polyps on its mantle to complete the disguise.

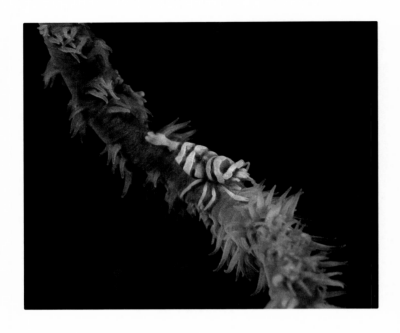

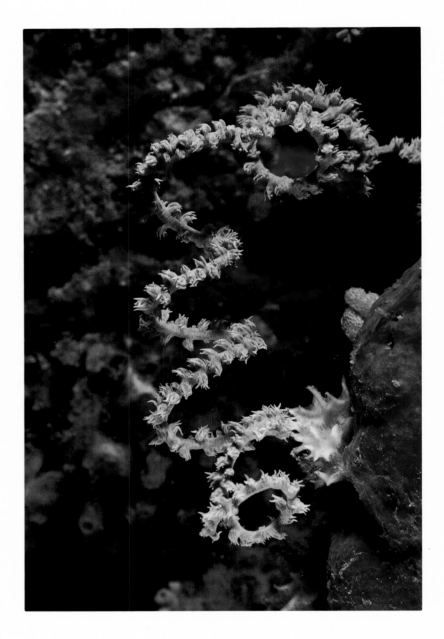

It was years before we ever saw more than a goby or two living on whips and wire corals. But because we're always on the lookout for aberrations, one day we took a closer look at a large lump protruding from a quarter-inch-diameter whip coral. As we adjusted our vision, the "lump" sprouted legs and turned into a crab. How can so much actually take place on a piece of matter that more closely resembles a tightrope than living coral? Balancing life upon life in this highwire act, pairs of gobies, shrimps, and crabs mature, breed, and die, all the while consuming bits of even smaller organisms caught by the downy tentacles of their host.

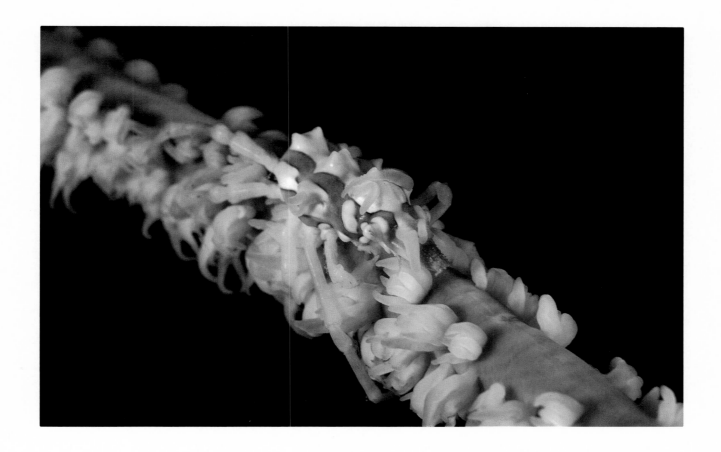

Crab on whip coral

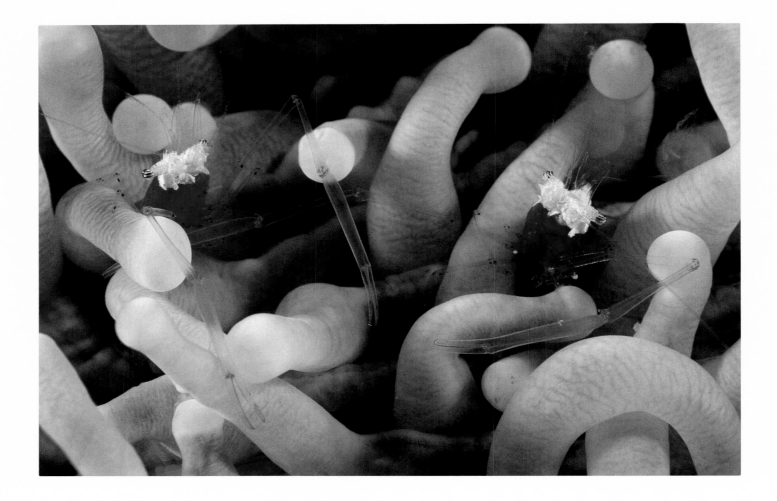

These two shrimp belong to the genus *Periclimenes*, the "janitors" of the reef. Periclimenes shrimp clean virtually every living surface on the reef: fish, invertebrates, or living coral. This species is cleaning a mushroom coral, a single-polyped, long-tentacled coral that resembles an anemone. These shrimp have developed such an intimate relationship with their host that they have evolved fuzzy white heads that resemble the coral's white-tipped tentacles.

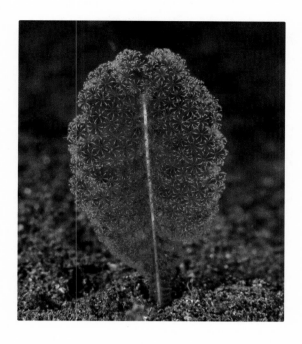

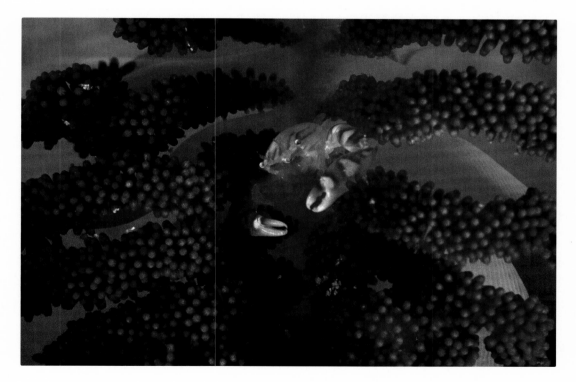

Sea pens, sand-dwelling soft corals, emerge from the sea floor at night, unfurl their polyp-covered branches, and reveal the living gems, such as this tiny commensal crab, tucked within.

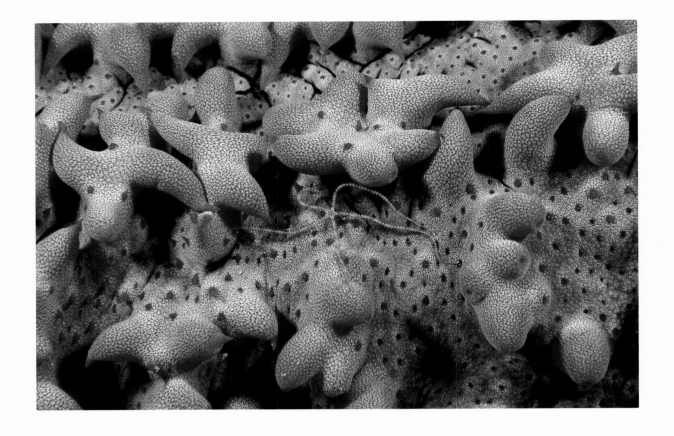

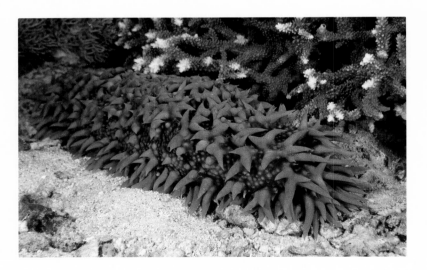

Sea cucumbers, vacuum cleaners of the reef, ingest large amounts of sand from which they extract edible, organic materials. A variety of symbionts, shrimps, crabs, fish, and worms, are attracted by this method of feeding, attaching themselves to the cucumber's skin and helping themselves to a portion of the cucumber's meal.

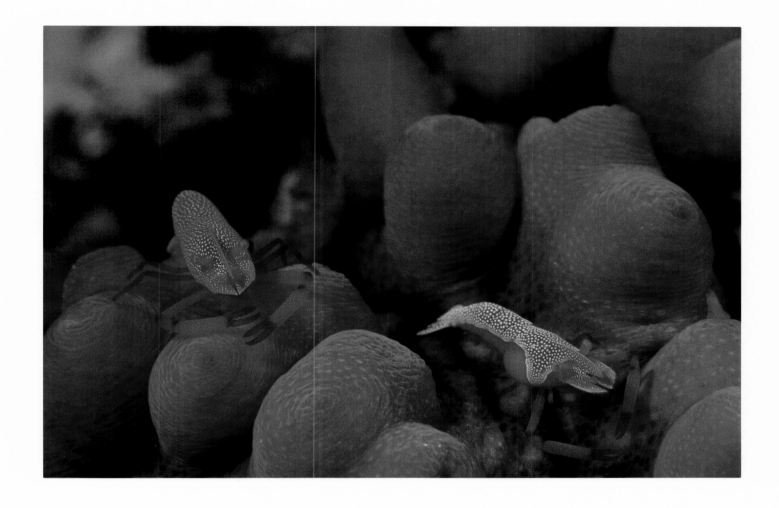

Two emperor shrimp on a sea cucumber

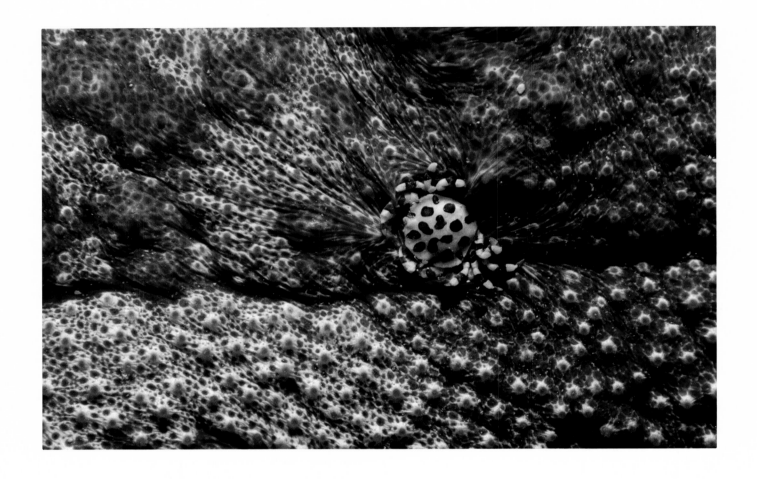

Commensal crab clinging to a sea cucumber

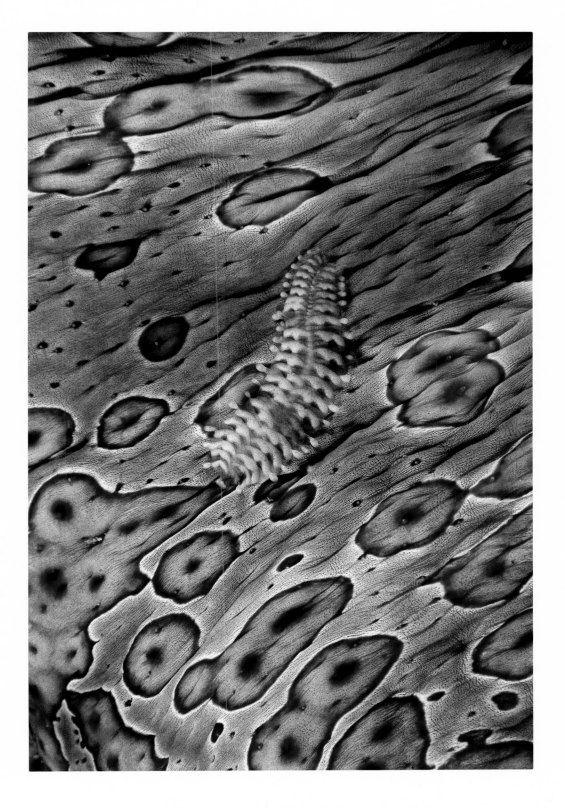

Scale worm on leopard sea cucumber

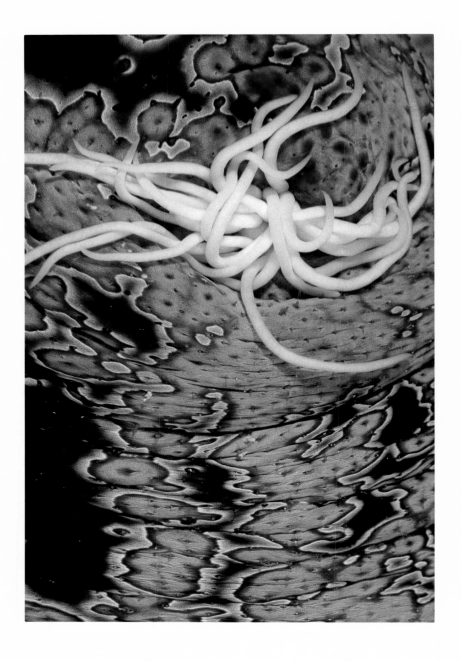

Eviscerating leopard sea cucumber ■ When threatened, the animal can
eviscerate part of its intestinal tract in the hope that a predator, satisfied
with a small offering, will not eat the entire organism. Any lost tissue is
quickly regenerated while uneaten material is pulled back into the body.

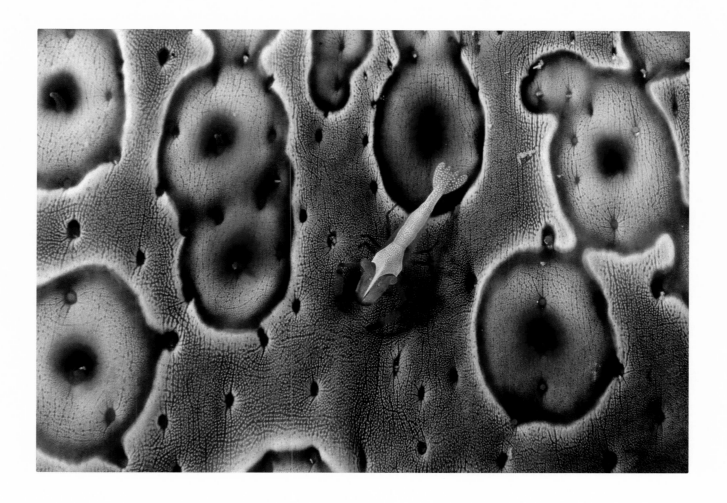

Emperor shrimp on sea cucumber

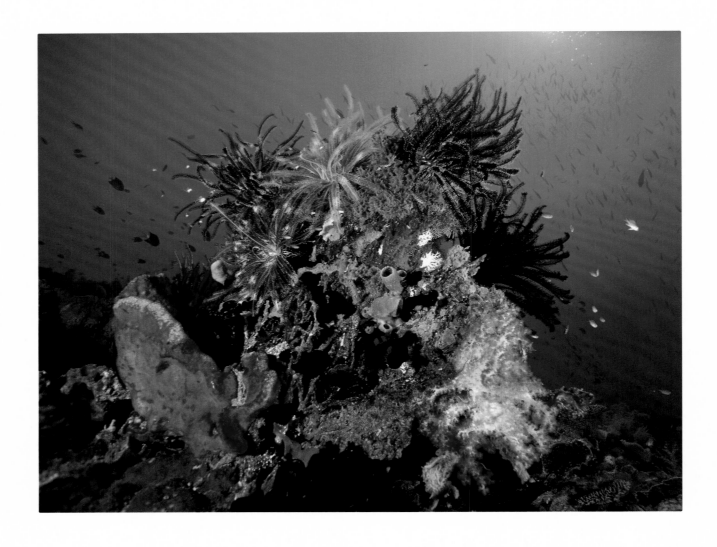

Living fossils, crinoids are the ancient ancestors of modern sea stars. Perched on sponges, gorgonians, and coral outcroppings, crinoids expose themselves to plankton-bearing currents. Their intricate body structure affords a sanctuary for numerous symbiotic animals.

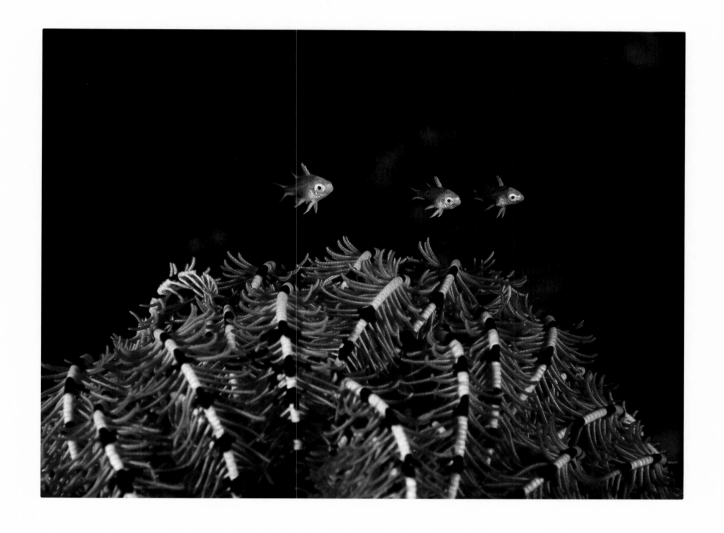

Juvenile damselfish hovering over a crinoid

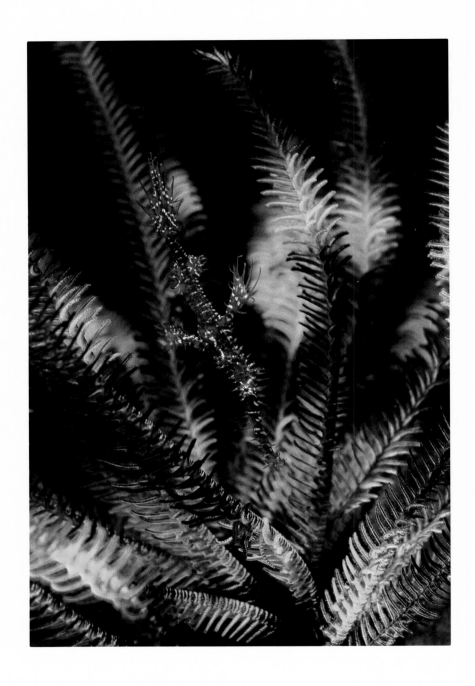

Ghost pipefish ▪ The spikes projecting from the pipefish's fins make it a virtual
lookalike for the feathery arms of the crinoid. By remaining motionless and
floating head down within the arms of its host, the pipefish takes
advantage of the crinoid's perfect refuge.

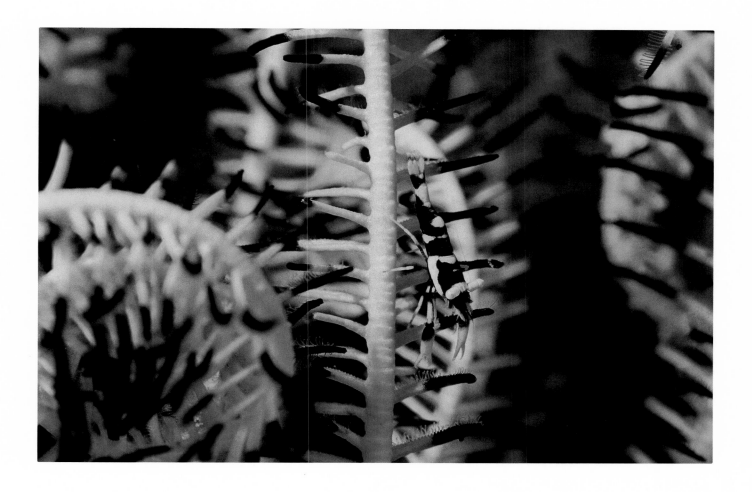

Commensal shrimp on crinoid ▪ These shrimp match their color to their host crinoid. If a shrimp were removed from one crinoid and placed on another, it would take a few weeks to blend in with its new host.

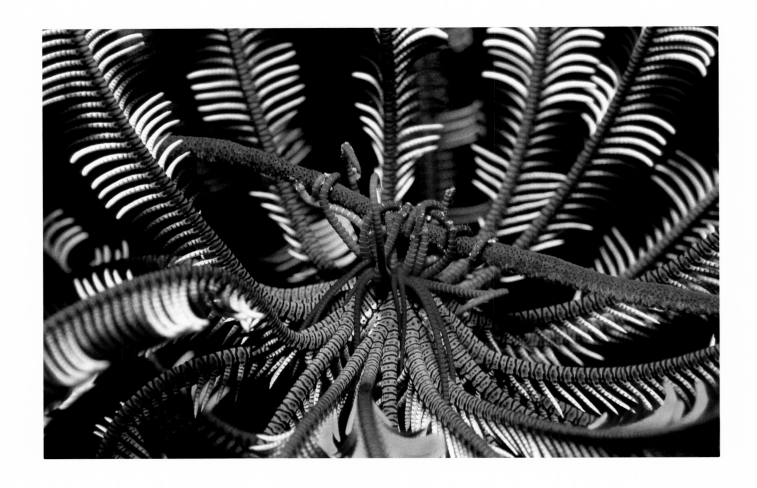

Crinoid cirri ■ Featherstars use their cirri, special clinging appendages on the ventral side of the crinoid, to climb to advantageous positions to feed in the current.

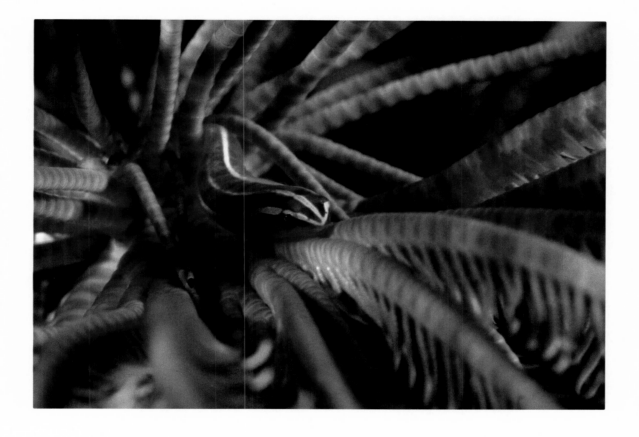

Two-stripe crinoid clingfish ▪ This two-inch-long symbiont lives among the feathery arms of a crinoid.
A ventral sucking disk allows the fish to hang onto its host even in a strong current.

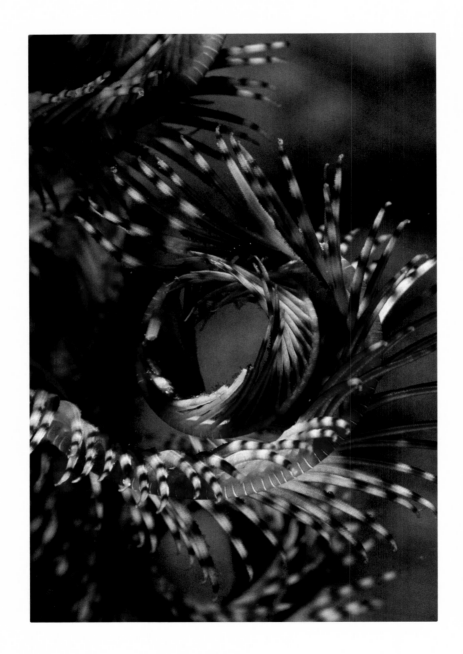

Crinoid arm

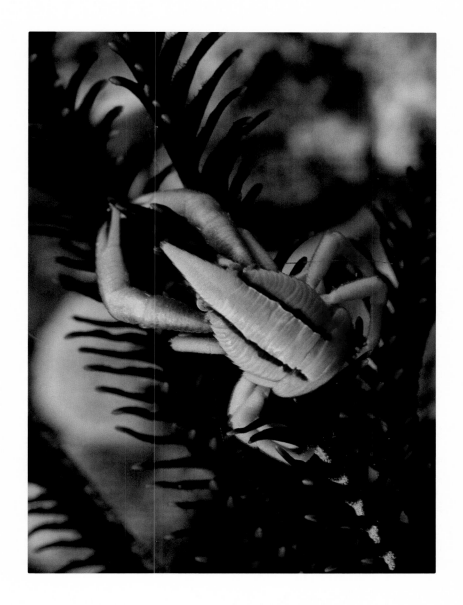

Elegant squat lobster on crinoid arm

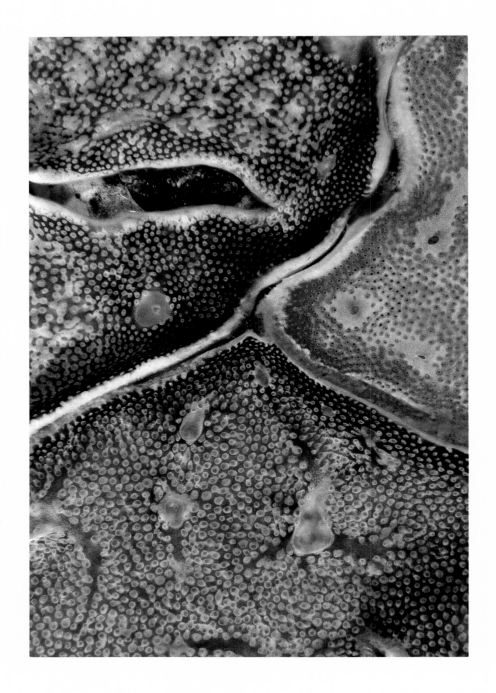

Ascidian collage ▪ Aberrations, collisions of textures and patterns, do more than
celebrate nature's inventiveness.  These abstract images document
territorial reef wars between encrusting and sessile animals.

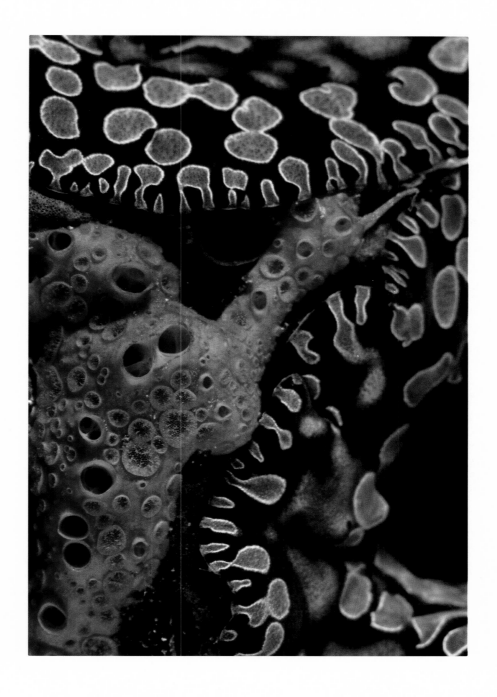

Sponge encrusting over *Tridacna* clam

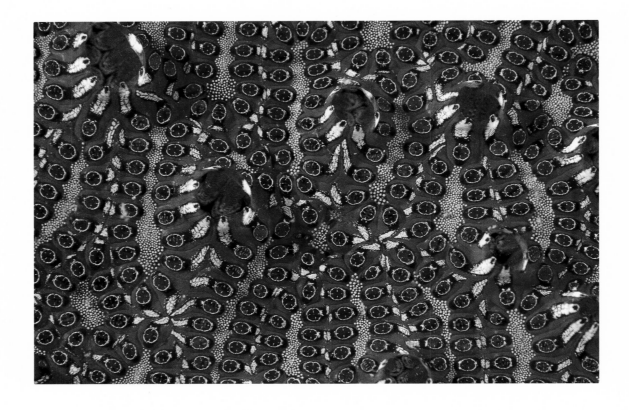

Encrusting ascidian ■ Like living geometry, every pattern found in the sea, whether it
be the radiating lines on an anemone, tightly packed schooling fish, or the sturdy
overlapping plates of a turtle's shell, is a fantastic display of each animal's
adaptation to the special circumstances of its environment.

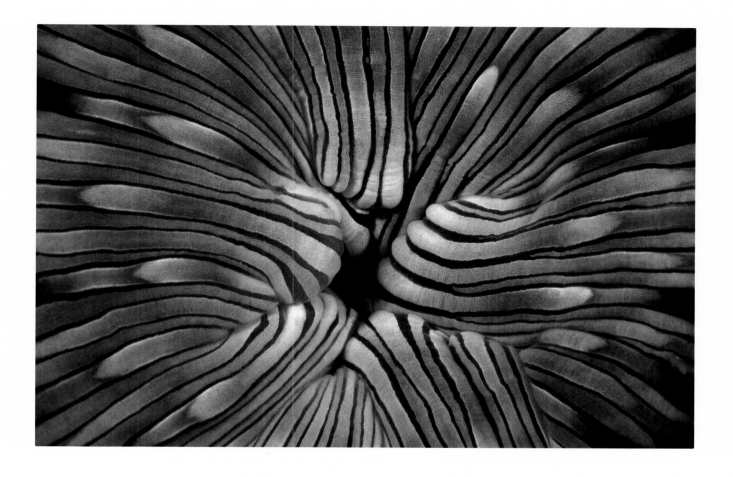

Ringed anemone mouth

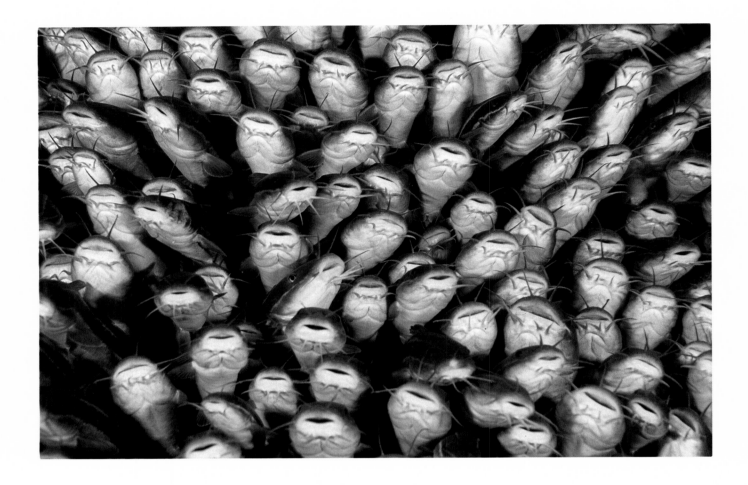

Poisonous striped catfish

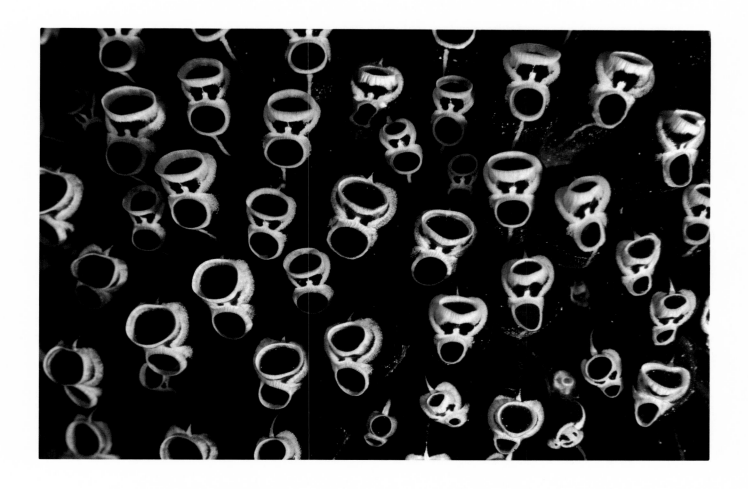

"Singing" tunicate faces

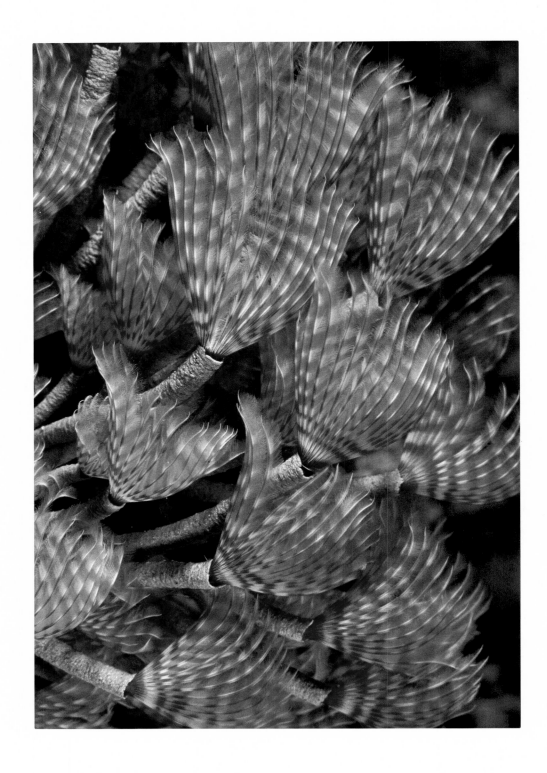

Feather duster worm colony

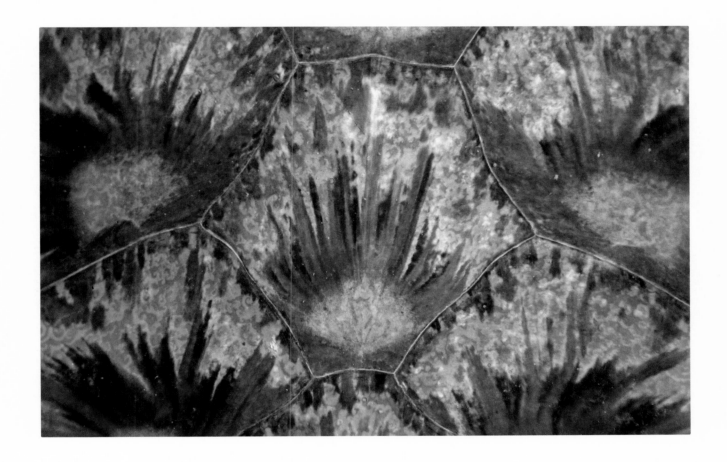

Green turtle carapace

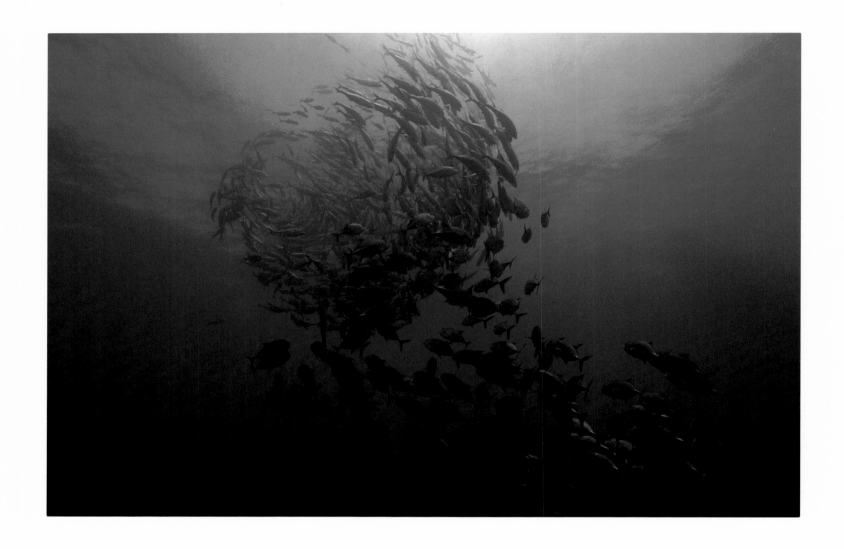

Swirling jacks

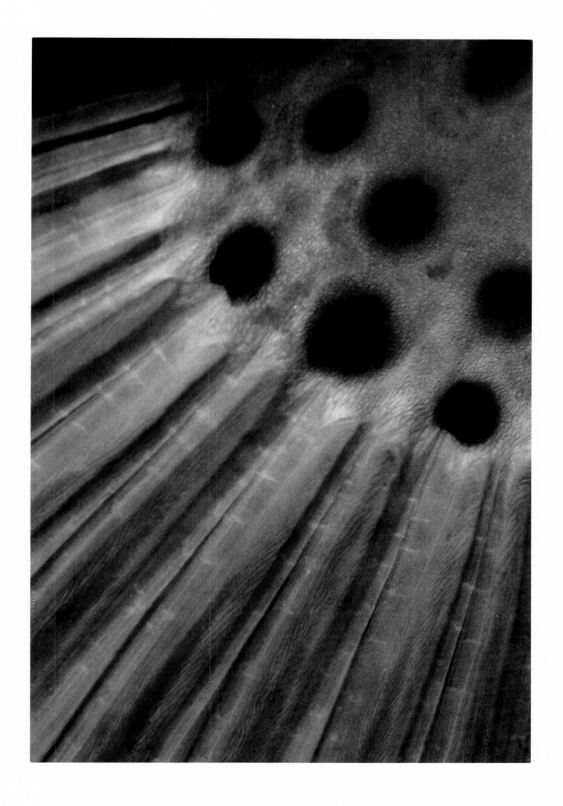

Scrawled filefish tail

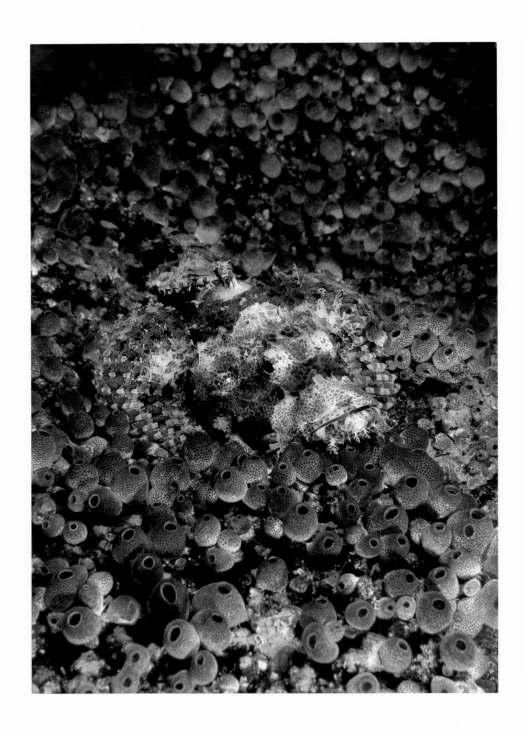

Scorpionfish in a bed of tunicates

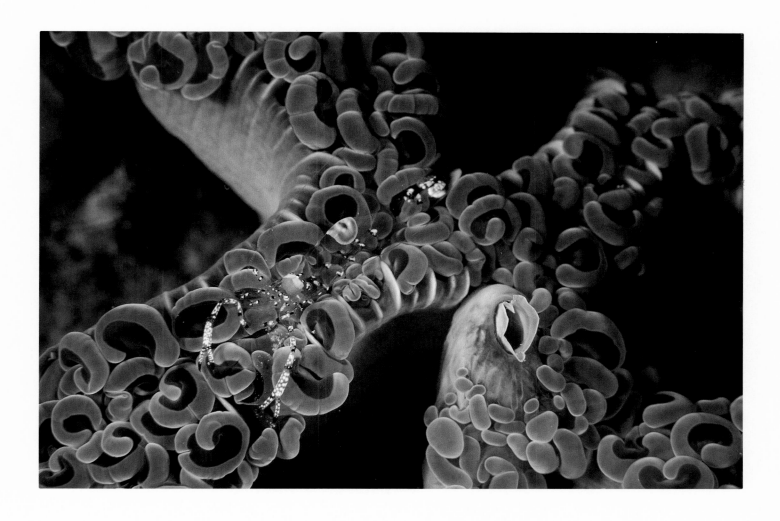

Cleaner shrimp on *Euphylia* coral ▪ Glance casually at the reef and you primarily see faint delineations of color, form, and texture. This is camouflage, nature's favorite handicapping system. In the sea, camouflage works two ways. It tips the scales in favor of species that, without it, might not survive; then shifts the balance back again so that species survive only in proportionate numbers.

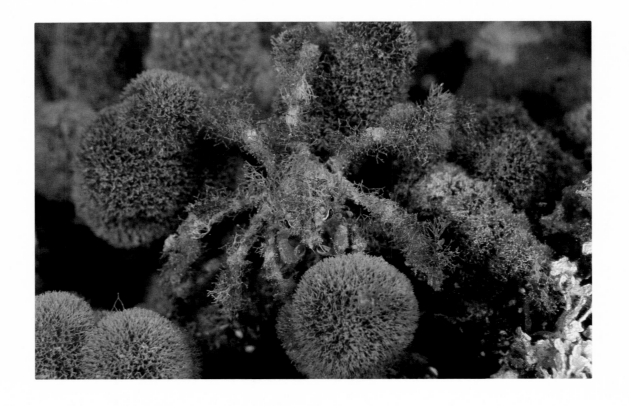

Spider crab with algae disguise

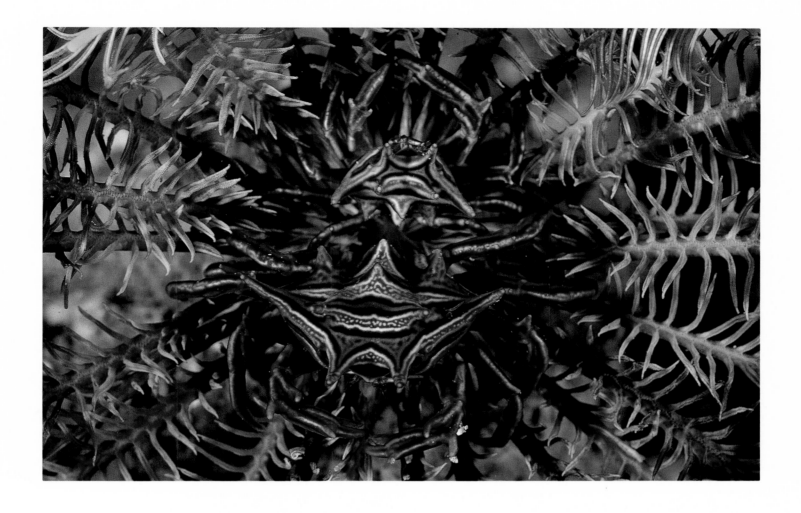

Two unidentified crinoid crabs

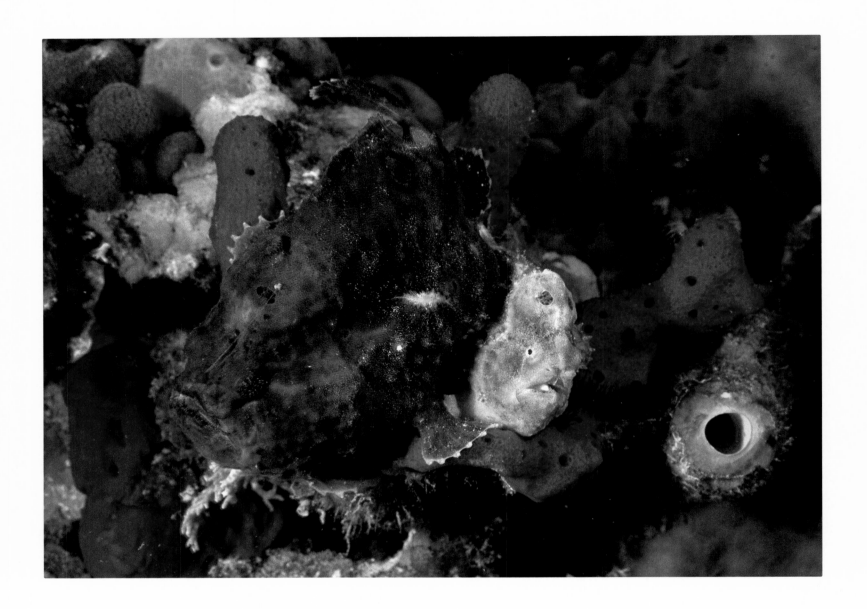

Two longlure frogfish among sponges

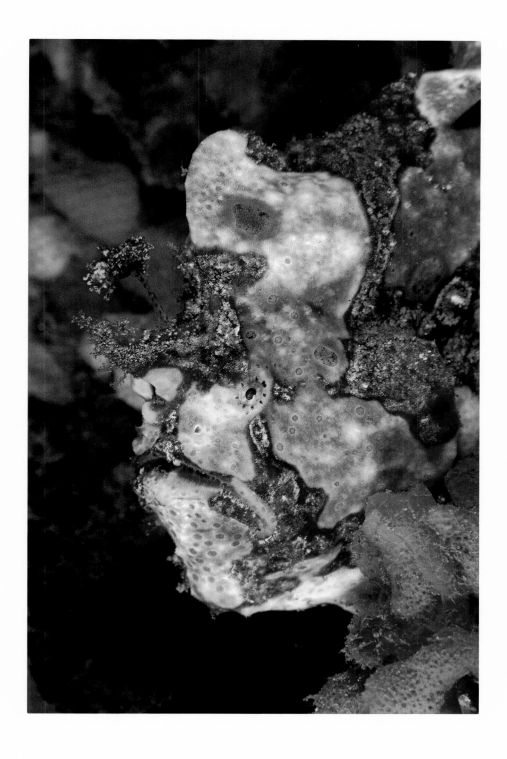

Giant anglerfish

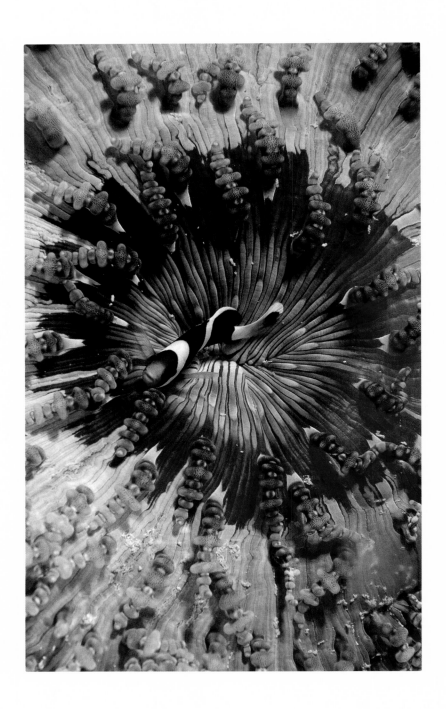

Ringed anemone with resident juvenile clownfish

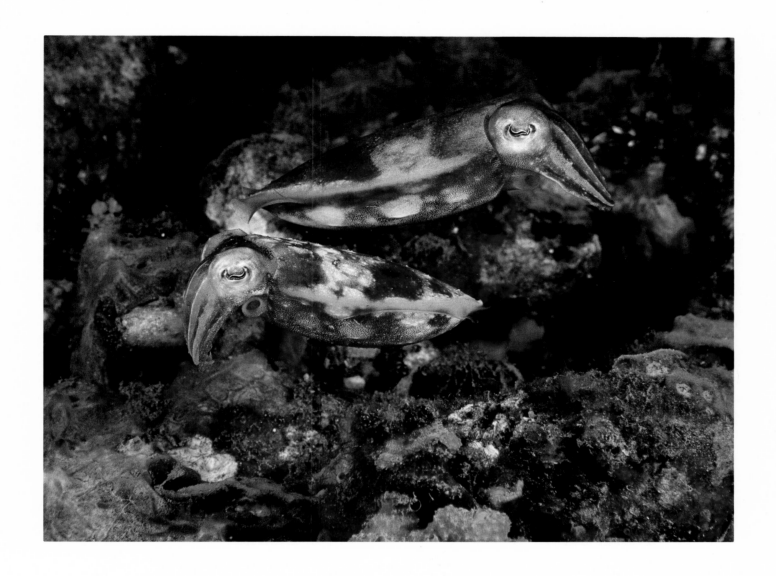

Pygmy cuttlefish pair

Decorator crab ▪ Awakened by our flashing strobe, a decorator crab searches for a new niche.
Covered with living Velcro—tiny hooked-shaped hairs called *setae*—the crab's shell and legs
tightly hold bits of sponge, coral, and hydroids, decorations that disguise the crab
and allow it to more easily surprise its prey.

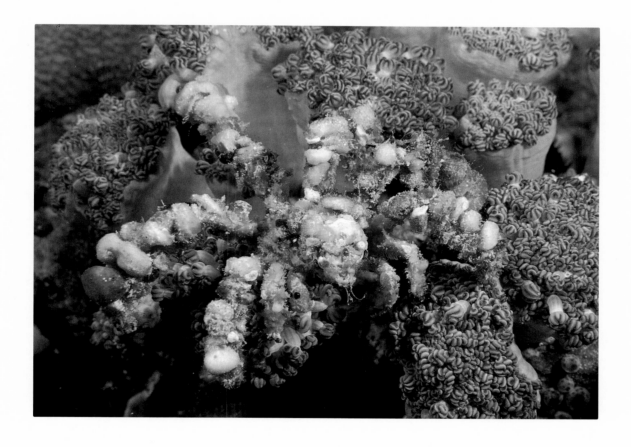

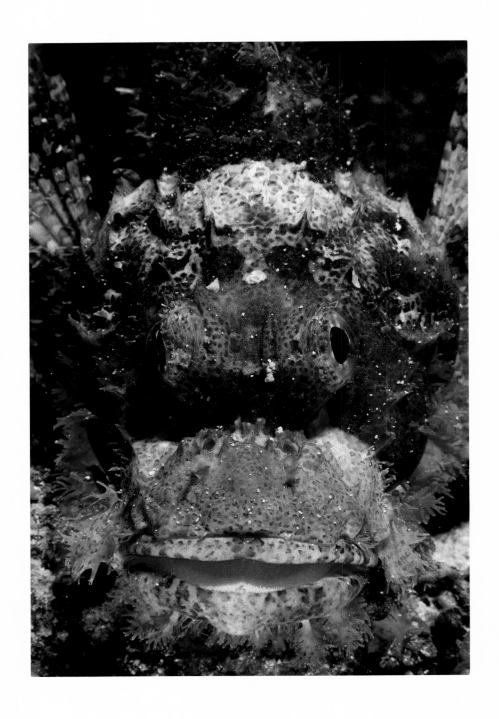

Scorpionfish, Sipadan Island

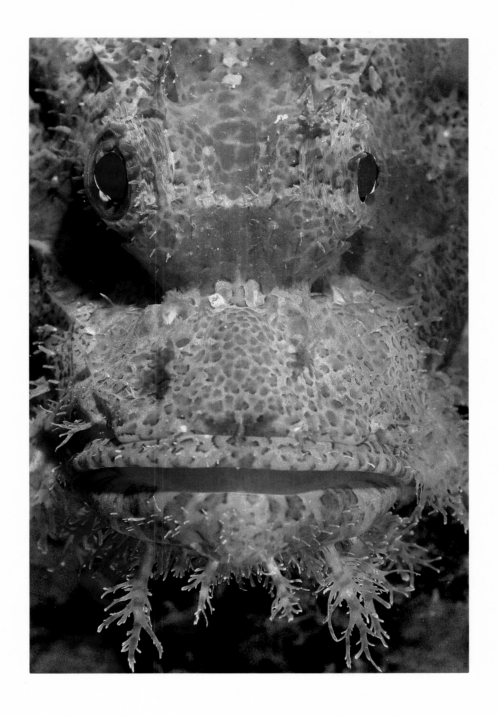

Scorpionfish, Solomon Islands

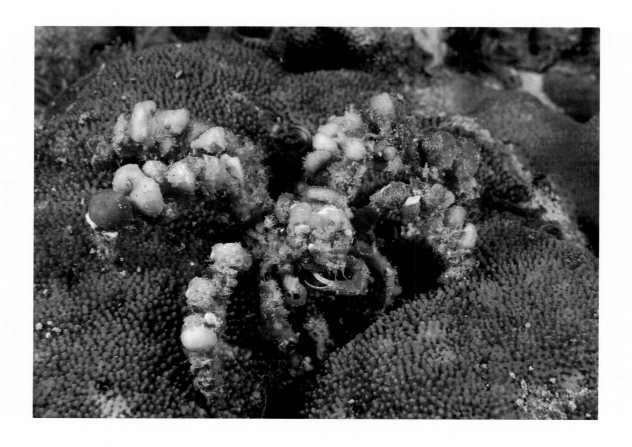

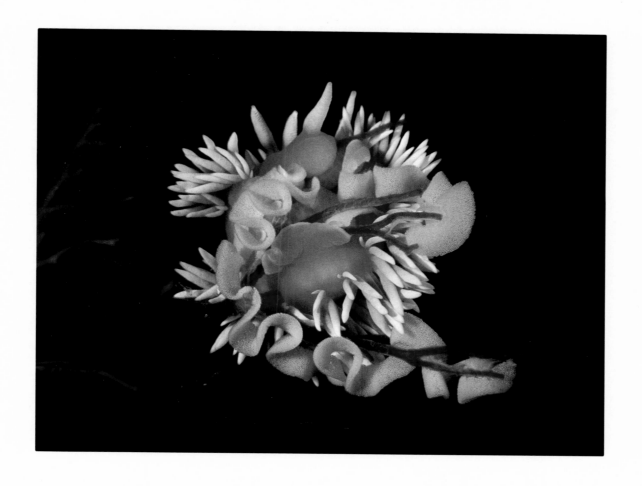

Nudibranch spinning egg ribbon

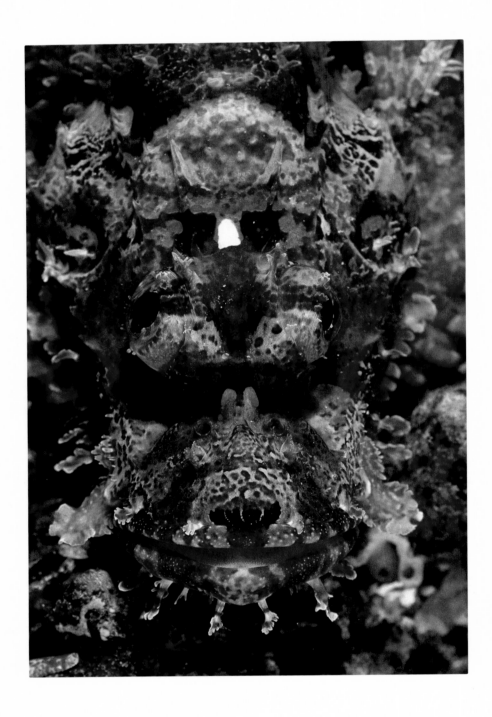

Scorpionfish, Fiji

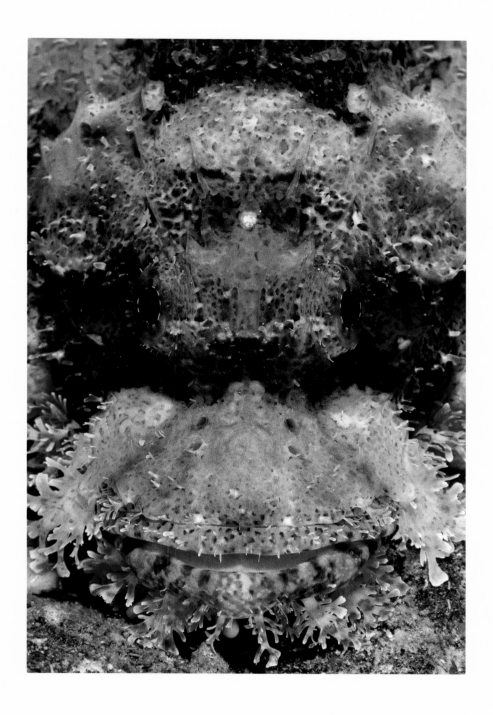

Scorpionfish, Red Sea

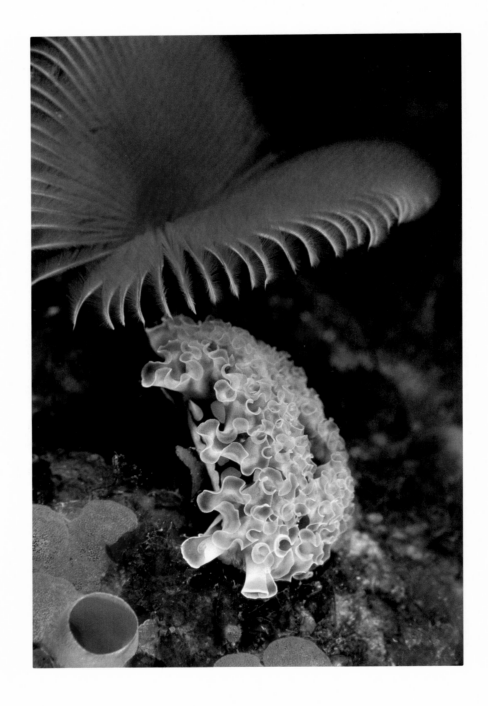

Lettuce slug

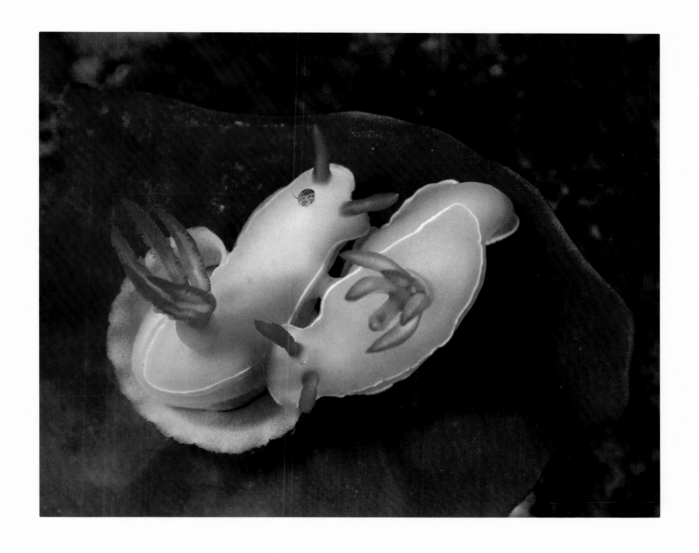

Mating nudibranchs laying their egg ribbon

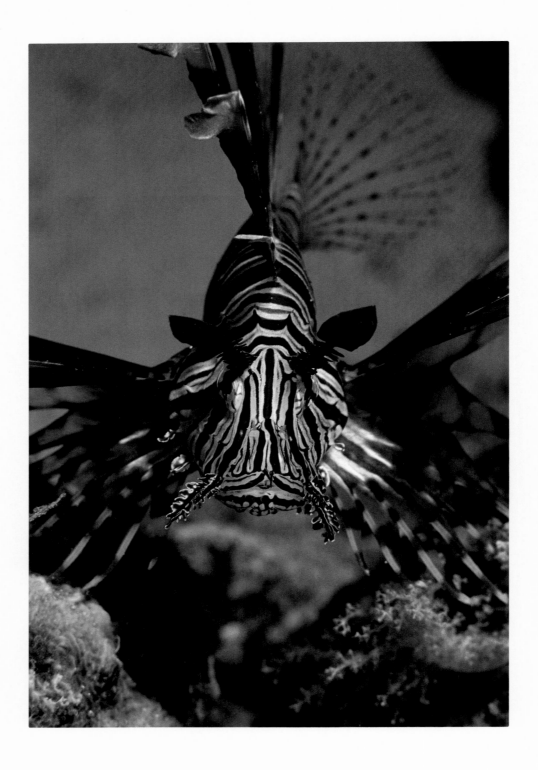

Lionfish

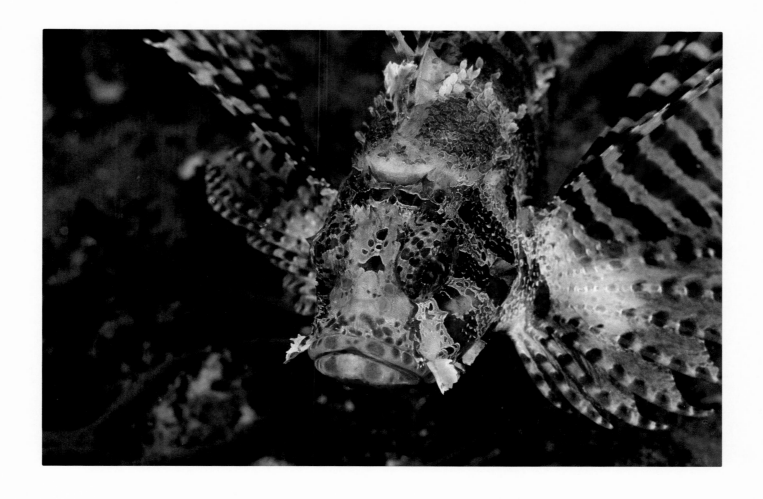

Dwarf lionfish, yellow phase

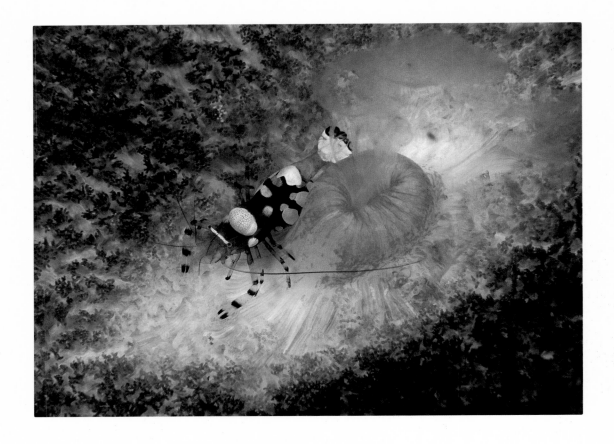

Shrimp on spawning anemone

Emperor shrimp on sea cucumber

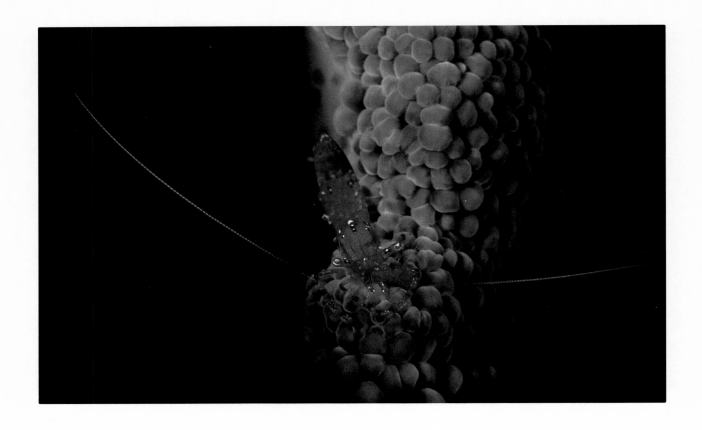

Cleaning shrimp on anemone

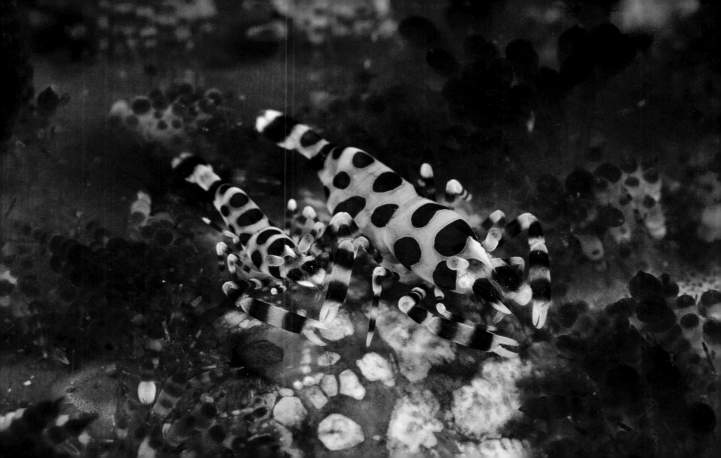

The taxonomy of marine animals is constantly evolving. In many cases the animals which we have photographed cannot be definitively identified without examining a specimen in the laboratory. We have, with assistance from Dr. Gerald R. Allen of the Western Australia Museum, identified the subjects in our photographs as completely as possible. The plate note information is provided solely as a general guide and should not be considered to represent scientific identification which, in some instances, could only be verified by physical examination.

1. Male squarespot anthias, *Pseudanthias pleurotaenia*, Sipadan, Malaysia

3. Juvenile lionfish, *Pterois volitans*, Sipadan, Malaysia

4. Lionfish, *Pterois volitans*, Solomon Islands

6. Parrotfish tail, *Scarus* sp., Vanuatu

7. Two-band anemonefish, *Amphiprion bicinctus*, Red Sea

8. Juvenile scorpionfish, *Scorpaenopsis oxycephalus*, Sipadan, Malaysia

9. Eviscerating corallimorpharian, *Amplexidiscus fenestrafer*, Solomon Islands

10. White-lined coral trout, *Anyperodon leucogrammicus*, Sipadan, Malaysia

11. Triplefin on invertebrate collage, *Helcogramma striata*, Banda Sea, Indonesia

12. Anemone mouth, *Heteractis magnifica*, Red Sea

13. Corallimorpharian mouth, *Amplexidiscus fenestrafer*, Sipadan, Malaysia

14. Lionfish hunting, *Pterois volitans*, Sipadan, Malaysia

16. Whitetip shark, *Triaenodon obesus*, Cocos Island, Costa Rica

18. Bannerfish, *Heniochus acuminatus*, Eastern Fields, Papua New Guinea

20. Soft coral and fusiliers, *Dendronephthya* sp., and *Caesio* sp., Kakaban, Indonesia

23. Blue-eyed triplefin, *Notoclinops segmentatus*, Poor Knights, New Zealand

24. Mating green turtles, *Chelonia mydas*, Sipadan, Malaysia

25. Reef at minus tide, Sipadan, Malaysia

26. Anemone with pink anemonefish, *Heteractis magnifica* with *Amphiprion perideraion*, Solomon Islands

27. Pink anemonefish, *Amphiprion perideraion*, Solomon Islands

28. Cleaner shrimp on anemone mantle, *Periclimenes holthuisi* on *Herteractis magnifica*, Solomon Islands

29. Pair of longfin bannerfish, *Heniochus acuminatus*, Banda Sea, Indonesia

30. Teira batfish, *Platax teira*, Sangalakki, Indonesia

31. Crab on poisonous sea urchin, *Zebrida adamsii* on *Aerosoma varium*, Ambon, Indonesia

32. Anemone with pink clownfish, *Heteractis magnifica* with *Amphiprion perideraion*, Sipadan, Malaysia

33. Jacks over reef, *Caranx sexfasciatus*, Sipadan, Malaysia

34. Spotted moray, *Gymnothorax moringa*, Dominica

35. Sea whips and reef fish, *Ellisella* sp., Sipadan, Malaysia

36. Shrimp in corallimorpharian mouth, *Pliopontonia furtiva* in *Amplexidiscus fenestrafer*, Sipadan, Malaysia

37. Porcelain crab and juvenile, *Neopetrolisthes ohshimai*, Solomon Islands

38. Soft coral, *Dendronephthya* sp., Banda Sea, Indonesia

39. Coral trout with cleaner wrasse, *Cephalopholis miniata* with *Labroides dimidiatus*, Sipadan, Malaysia

40. Marbled rays, *Taeniura meyeri*, Cocos Island, Costa Rica

41. Schooling jacks, *Caranx sexfasciatus*, Banda Sea, Indonesia

42. Goatfish over sand flats, *Mulloides flavolineatus*, Sipadan, Malaysia

43. Garden eels, *Gorgasia* sp., Komodo, Indonesia

44. Devil's scorpionfish, *Inimicus* sp., Sangalakki, Indonesia

45. Cuttlefish, *Sepia* sp., Sangalakki, Indonesia

46. Shrimp gobies and blind shrimp, *Ctenogobiops tangaroai* and *Alpheus* sp., Ambon, Indonesia

48. Gold-spectacled jawfish, *Opistognathus* sp., Sangalakki, Indonesia

49. Bubble shells, *Hydatina physis*, Ambon, Indonesia

50. Atlantic spotted dolphins, *Stenella frontalis*, The Bahamas

51. Scalloped hammerhead sharks, *Sphyrna lewini*, Cocos Island, Costa Rica

52. Spinecheek anemonefish, *Premnas biaculeatus*, Kimbe Bay, Papua New Guinea

53. Table coral with anthias, *Acropora* sp., with *Pseudanthias* sp., Sipadan, Malaysia

54. Swimming crab with hydroids, *Portunus* sp., Sipadan, Malaysia

55. Stonefish, *Synanceia verrucosa*, Kimbe Bay, Papua New Guinea

56. Corallimorpharians, *Amplexidiscus fenestrafer*, Sipadan, Malaysia

57. Bubble coral, *Pleurogyra sinuosa*, Kakaban, Indonesia

58. School of bannerfish, *Heniochus acuminatus*, Eastern Fields, Papua New Guinea

59. Great barracuda, *Sphyraena barracuda*, The Bahamas

60. Mangrove roots, *Rhizophora* sp., Kakaban, Indonesia

61. Mangrove tree, *Rhizophora* sp., Kakaban, Indonesia

62. Banded sea krait, *Laticauda* sp., Ligitan, Malaysia

63. Mangroves with jellyfish, *Rhizophora* sp., with *Mastigias* sp., Kakaban, Indonesia

64. Gray shark in volcanic crevice, *Carcharhinus amblyrhynchos*, Solomon Islands

66. Invertebrate-encrusted thorny oyster, *Spondylus varius*, Sipadan, Malaysia

67. Crinoids embroidering a sea fan, Solomon Islands

68. Sea fans, *Subergorgia* sp., Vanuatu

69. Sea fan, *Subergorgia* sp., Sangalakki, Indonesia

70. Brittlestars, *Ophiothela danea*, entwined in sea fan, Kakaban, Indonesia

71. Longnose hawkfish, *Oxycirrhites typus*, Sipadan, Malaysia

72. Unidentified decorator spider crab, Matagi, Fiji

73. Trumpetfish, *Aulostomus chinensis*, Sipadan, Malaysia

74. Variegated sea fan, *Subergorgia* sp., Solomon Islands

75. Goby on sea fan, *Bryaninops loki* on *Subergorgia* sp., Solomon Islands

76. Sea fan polyps, *Subergorgia* sp., Solomon Islands

77. Camouflaged translucent goby, *Pleurosicya mossambica*, Banda Sea, Indonesia

78. Colonial anemones, *Amphianthus* sp., Banda Sea, Indonesia

79. Colonial anemones with threadfin hawkfish, *Amphianthus* sp., with *Cirrhitichthys aprinus*, Banda Sea, Indonesia

80. Plate coral colony, *Montipora* sp., Matagi, Fiji

81. Goby on star coral, *Eviota queenslandica* on *Montastrea magnistellata*, Sipadan, Malaysia

82. Christmas tree worm, *Spirobranchus giganteus*, Solomon Islands

83. Hermit crab in hard coral, *Paguritta harmsi*, Solomon Islands

84. Aberration on hard coral, *Patisseries speciosa*, Sangalakki, Indonesia

84. Budding leather coral, *Sarcophyton* sp., Kakaban, Indonesia

85. Budding leather coral, *Sarcophyton* sp., Banda Sea, Indonesia

86. Open/closed octocoral, unidentified, Sipadan, Malaysia

87. Hard coral, *Goniopora* sp., Solomon Islands

88. Table coral with soft coral, *Acropora* sp., with *Dendronephthya* sp., Matagi, Fiji

89. Golden hawkfish, *Cirrhitichthys aureus*, Labuan, Malaysia

90. Soft coral "mirror image," *Dendronephthya* sp., Solomon Islands

91. Many-host goby, *Pleurosicya mossambica*, Red Sea

92. Decorator crab on soft coral, *Hoplophrys oatesii* on *Dendronephthya* sp., Solomon Islands

93. Leather coral, *Sarcophyton* sp., Sangalakki, Indonesia

94. Leather coral, *Sarcophyton* sp., Kimbe Bay, Papua New Guinea

95. Two leather coral colonies, *Sarcophyton* sp., Kimbe Bay, Papua New Guinea

96. Leather coral polyps, *Sarcophyton* sp., Solomon Islands

97. Scorpionfish in leather coral, *Scorpaenopsis oxycephalus* in *Sarcophyton* sp., Komodo, Indonesia

98. Leaf scorpionfish, *Taenianotus triacanthus*, Sangalakki, Indonesia

99. Soft coral, *Sinularia* sp., Banda Sea, Indonesia

100. Flower coral, *Xenia* sp., Sangalakki, Indonesia

101. Flower coral polyps, *Xenia* sp., Sangalakki, Indonesia

102. Orangutan crab on bubble coral, *Achaeus japonicus* on *Physogyra lichtensteini*, Vanuatu

103. Shrimp on bubble coral, *Vir philippinensis* on *Physogyra lichtensteini*, Kakaban, Indonesia

104. Sea whip colony, *Ellisella* sp., Solomon Islands

105. Trumpetfish in sea whips, *Aulostomus chinensis* in *Ellisella* sp., Matagi, Fiji

106. Sea whip polyps, *Ellisella* sp., Solomon Islands

107. Spindle cowry on sea whip, *Phenacovolva* sp., on *Ellisella* sp., Sipadan, Malaysia

108. Shrimp on wire coral, *Dasycaris zanzibarica* on *Cirrhipathes* sp., Sipadan, Malaysia

108. Spiraling wire coral, *Cirrhipathes spiralis*, Sipadan, Malaysia

109. Crab on whip coral, *Xenocarcinus tuberculatus* on *Uunceela fraglis*, Sangalakki, Indonesia

110. Cleaner shrimp on mushroom coral, *Periclimenes kororensis* on *Heliofungia actiniformis*, Sangalakki, Indonesia

111. Sea pen, *Virgularia* sp., Flores, Indonesia

111. Sea pen, *Virgularia* sp., with unidentified commensal crab, Flores, Indonesia

112. Sea cucumber, *Thelenota ananas*, Kimbe Bay, Papua New Guinea

112. Unidentified brittlestar on sea cucumber, *Thelenota ananas*, Kimbe Bay, Papua New Guinea

113. Two emperor shrimp on sea cucumber, *Periclimenes imperator* on *Thelenota ananas*, Sipadan, Malaysia

114. Crab on sea cucumber, *Lissocarcinus orbicularis* on *Thelenota anax*, Magati Fiji

115. Scale worm on leopard sea cucumber, *Gastrolepidia clavigera* on *Bohadschia argus*, Sangalakki, Indonesia

116. Eviscerating leopard sea cucumber, *Bohadschia argus*, Vanuatu

117. Emperor shrimp on sea cucumber, *Periclimenes imperator* on *Bohadschia argus*, Banda Sea, Indonesia.

118. Crinoids on a sponge, Banda Sea, Indonesia

119. Juvenile damselfish, *Amblyglyphidodon aureus*, Komodo, Indonesia

120. Harlequin ghost pipefish, *Solenostomus paradoxus*, Banda Sea, Indonesia

121. Commensal shrimp on crinoid, *Periclimenes* sp., Banda Sea, Indonesia.

122. Crinoid cirri, Solomon Islands

123. Two-stripe crinoid clingfish, *Discotrema lineata*, Matagi, Fiji

124. Crinoid arm, Red Sea

125. Elegant squat lobster, *Allogalathea elegans*, Kakaban, Indonesia

126. Ascidian collage, *Aplidium* sp., Sangalakki, Indonesia

127. Sponge encrusting over *Tridacna* clam, sponge order Hadromerida, clam, *Tridacna crocea*, Fiji

128. Encrusting ascidian, *Botrylloides leachi*, Kakaban, Indonesia

129. Ringed anemone mouth, *Heteractis aurora*, Sangalakki, Indonesia

130. Poisonous striped catfish, *Plotosus lineatus*, Ambon, Indonesia

131. "Singing" tunicates, *Clavelina* sp., Solomon Islands

132. Feather duster worm colony, *Bispira brunnea*, Puerto Morelos, Mexico

133. Green turtle carapace, *Chelonia mydas*, Sipadan, Malaysia

134. Swirling jacks, *Caranx sexfasciatus*, Sipadan, Malaysia

135. Scrawled filefish tail, *Aluterus scriptus*, Sipadan, Malaysia

136. Scorpionfish in a bed of tunicates, *Scorpaenopsis oxycephalus* in *Didemnum molle*, Sipadan, Malaysia

137. Cleaner shrimp on coral, *Periclimenes* sp. on *Euphylia ancora*, Sangalakki, Indonesia

138. Spider crab with algae disguise, *Camposcia retusa*, Ambon, Indonesia

139. Two unidentified crinoid crabs on host, Red Sea

140. Two longlure frogfish among sponges, *Antennarius multiocellatus*, Dominica

141. Giant anglerfish, *Antennarius commersoni*, Ambon, Indonesia

142. Ringed anemone with clownfish, *Amphiprion clarki* with *Heteractis aurora*, Sangalakki, Indonesia

143. Pygmy cuttlefish pair, *Sepia* sp., Ambon, Indonesia

144-146. Decorator crab, (all same subject,) *Camposcia retusa*, Banda Sea, Indonesia

147. Scorpionfish face, *Scorpaenopsis oxycephalus*, Solomon Islands

148. Scorpionfish face, *Scorpaenopsis oxycephalus*, Sipadan, Malaysia

149. Scorpionfish face, *Scorpaenopsis oxycephalus*, Red Sea

150. Scorpionfish face, *Scorpaenopsis oxycephalus*, Matagi, Fiji

151. Nudibranch spinning egg ribbon, *Jason mirabilis*, Poor Knights, New Zealand

152. Lettuce slug, *Tridachia crispata*, Dominica

153. Nudibranchs laying their egg ribbon, *Chromodoris bullocki*, Komodo, Indonesia

154. Lionfish, *Pterois volitans*, Banda Sea, Indonesia

155. Dwarf lionfish, yellow phase, *Dendrochirus brachypterus*, Ambon, Indonesia

156. Shrimp on anemone, *Periclimenes brevicarpalis* on *Cryptodendrum adhaesivum*, Bismarck Sea, Papua New Guinea

157. Emperor shrimp on sea cucumber, *Periclimenes imperator* on *Stichopus variegatus*, Kimbe Bay, Papua New Guinea

158. Cleaning shrimp on anemone, *Periclimenes holthuisi* on *Stichodactyla* sp., Vanuatu

159. Coleman's shrimp on poisonous sea urchin, *Periclimenes colemani* on *Aerosoma varium*, Ambon, Indonesia

° Lewis Thomas, *The Lives of a Cell: Notes of a Biology Watcher*, Bantam Books, New York. 1975

# A c k n o w l e d g e m e n t s

The photographs in this book, like the life that we share, represent a collaborative vision. As photographers, we have different temperaments, styles, and abilities, but we are both in pursuit of the same quarry. We know what we are looking for, and we know when one or the other of us has found it.

Though we dive together, we work separately. By nature, Burt is meticulous, technical-minded, and normally in the micromode. I usually search for wide-angle vistas. We find this division of labor works well for us. It enables each of us to focus our attention on our field of endeavor without worrying about what we might be missing on another part of the reef.

Both of us are totally self-taught. When we first started out, our heads were filled with images we wanted to reproduce, but it took long years to mesh our imaginations with our capabilities and our desires with the limitations of our equipment. Although these days we are trying to streamline and incorporate some of the advances in focusing and metering technology into our gear, a few items have remained constant: Two strobes and a powerful modeling light for the macro work, and an external light meter with two wide-coverage strobes mounted on long, flexible arms for the wide-angle photos. We have consistently used Nikon cameras, the sturdy F-3's and most recently the sleek N-90's. A variety of housings—Aquatica, Ikelite, Nexus, and Subal—have protected these wonderful camera bodies. Oceanic strobes provided our underwater light for many years. Today we use easily adjusted Technical Lighting Control arms mounted with Sea and Sea strobes capable of TTL metering. In the beginning, we chose Fuji film because we could develop it ourselves and get instant feedback on the day's shoot. We continue to use Fuji film because of its fine grain quality and its extremely saturated rendition of the reef's glorious colors.

Finally, a word about how this book is organized. *Secret Sea* is not about individual images, but about connections. During the many years we planned this book, our goal was always to present still photographs in a way that would allow them to act as dynamic interpreters. We began by arranging the images in series from magnificent reef panoramas down to the subtle structural details of a coral polyp. Move through the series in this book however you choose, from big to little, macro to wide-angle, or push out from the center like the radiating arms of a sea star. Our intention is to make each series unique, and to make the interplay between the photographs as intriguing as the individual images themselves.

A first book is a very special undertaking. *Secret Sea* would not have become a reality without support from our families and friends. Even though we know that our immediate family, Barbara, Vivian, Sol, Beth, Brent, Peter, and Stacey, thought us certifiably crazy after hearing about our sometimes wild adventures, they have always encouraged us. Our large "extended" family in and around Austin, Vickie Karp, Nancy Reddeman and Doug Gurkin, Ross and Roseann Curtis, Lin Altman and John Broders, Bert and Vicki Horn, Jim and Melany McClurg, David Henderson, Devon Dederich, and Tom and Janice Robinson, have cheered our successes and consoled us during bleak times.

Certain people have supported our career from its inception. In many cases their suggestions tightened our focus and sharpened our work. Dr. Helmut Gernsheim was the first photography collector to recognize the "art in the animal." We are proud to be the principle marine life photographers in his extensive collection. The renowned photographer Fritz Henle and his wonderful family took our work to The Ransom Center at The University of Texas, and we became the first underwater photographers represented there. Natalie Jones, curator of the AT&T Collection, created a special exhibition, Sea Visions, an expansive display for our large-format prints.

Time in the field is one of the most crucial elements for marine life photographers. We could not have taken a large portion of the photographs in this book were it not for the unselfish and always generous gift of time given to us by our close friends, the Borneo Divers: Ron Holland, Randy Davis, Clement Lee, Samson Shak, and their staff. We have also been given the opportunity to photograph at many other fine resorts and well-run live-aboards, including the M/V *Bilikik*i, the M/V *Kiwi Diver*, Max Benjamin's glorious Walindi Plantation, Alan Raabe's M/V *FeBrina*, the Douglas Family's wonderful Matagi Island Resort, M/V *Matagi Princess*, and Fred and Corina Douglas's M/V *Solomon Sea*. In Mexico, Mike and Gabby Madden and their staff at the CEDAM Dive Center have always welcomed us and made us feel at home.

We have relied on many people to get us in and out of exotic locations and to organize the diving adventures we sometimes lead. In addition to being a good friend and an enthusiastic supporter, Ken Knezick of Island Dreams Travel has worked tirelessly to organize many outrageously complicated itineraries for us and our groups. Carl Roessler of See and Sea Travel, Inc. has generously promoted both our photography and travel programs. We have enjoyed great food, wine, and incomparable airline service with Fred and Jane Siems of Malaysia Airlines.

Several people have been instrumental in publishing our work and helping us reach the public. We'll never forget our first nervous visit to a crowded little house on Sunset Road in San Antonio, Texas. Our soon-to-be friends and keen dive buddies, Charlene deJori and Cheryl Schorp of *Ocean Realm* magazine, recognized in us two kindred spirits. And since that winter day in 1989 they have steered us faithfully in the right direction so that others may share in our vision of the underwater world. All four of us are glad that Kay Harford, Sandra Bonham, and Margaret Batschelet have been in the office to sort out the many confusions.

Helmut Debelius of IKAN, the staff of NHPA, and Photographers Aspen have successfully represented our work around the world. Helen Gilks was instrumental in introducing our photography to the European audience. Nan Richardson and Catherine Chermayeff of Umbra Editions and Elliot Landy of LandyVision provided early support and encouragement.

From the moment we walked through the doors at Dynagraphics, Inc. in Portland, we were treated like old friends. We knew instantly that Char and Byron Liske's staff could handle the responsibility of turning a collaborative concept between photographers and designers into the book you now hold in your hands. Without Dynagraphics' unflinching commitment to the highest standards of color separations and printing, the photographs in *Secret Sea* would not have come alive on the printed page.

Without state-of-the-art equipment we could not have realized our dream. We have lost count of the many times Eric Peterson, returning to his family after several exhausting weeks on the road, has stopped a few highway exits short of home to bring us a much-needed piece of diving equipment. With generosity and great humor, Mario Valenzuela of Sea Quest has kept us smiling and supplied with quality Sea Quest gear. Bob Hollis of Oceanic, George Brandt of U. S. Divers, and Chauncey Chapman have always done their best to invent ways to fulfill our unconventional requests.

No one responds more kindly to cries of "help" at odd hours of the day or night than Julius Pignataro of Sea & Sea. His talent for configuring electronic camera equipment that actually works in salt water is legendary. Resurrecting drowned cameras requires patience, curiosity, and genius. Since the beginning of our careers, Bob and Gwen Warkentin and their staff at Southern Nikonos have listened to our tales of woe and patiently brought our treasured Nikonos cameras back to life. Dan Auber, Frank Fennell and Stanley Menscher of Nikon, Fred Dion of Underwater Photo-Tech, and Michael Fattori of Princeton Tec have been gracious with their advice and generous with their support.

The question we are most often asked is "How did you do that?" In many ways, the answer lies in the inventiveness of the camera housing manufacturers. These beautifully designed, precisely manufactured cases protect the high tech cameras that allow us to reveal the sea's secrets. Since we purchased our first Aquatica housing, it has been our "workhorse," the one we could always count on. Throughout the years, we have maintained a wonderful dialogue with Stanley Hopmeyer and John Paul of Aqua Vision. Without the kind assistance of Toshikazu Kozawa of Anthis, we never would have known the joys of using the compact and lightweight Nexus housing.

Without an audience, what we do would have little meaning. Over the years we have subjected the members of the Houston Underwater Club, the Houston Underwater Photographers Society, and the River City Dive Club of San Antonio to many repeat performances of slide shows in production. We would like to thank all of our friends in Houston and San Antonio, for their patience and constructive criticism.

The reasons we love to dive and photograph under the sea are many and varied. One of the most important is the camaraderie of the dive community. We have been extremely fortunate to share some of the best times of our lives with an extraordinary group of dive buddies: Bert and Vicki Horn, who fell in love with diving after we certified them in 1984 and have since traveled with us to the ends of the earth; Daniel and Pauline D'Orville, talented photographers who make Kuala Lumpur feel like home; Larry Smith, the best divemaster on earth; Kal Muller, our wandering friend who has shared the secrets of Indonesia's spectacular diving with us; Dr. Gerald Allen and Roger Steene, diving's first couple of comedy; Dr. James Lynch, who soothed our souls with wine and song and then held our hands with wide-eyed anticipation of his first underwater adventure; and intrepid divers, fearless travelers, and friends: David Hall and Gayle Jamison, John and Kate Shobe, Norbert Wu, Wes Skiles, Steve Harrigan, Chuck Stevens, Bill and Holly Broussard, Ralph and Karen Erickson, Gail and Richard Todd, Frank Mahar, and Heidi Munday. Finally, we want to express our gratitude for the laughter and tears we shared with our dear friend Marjorie Bank, whom we miss more than we can say.

PUBLISHER
Fourth Day Publishing, Inc.
San Antonio, Texas

EXECUTIVE EDITOR
Cheryl Schorp
San Antonio, Texas

DESIGN
Charlene deJori
San Antonio, Texas

COLOR & PRINTING
Dynagraphics, Inc.
Portland, Oregon